STANMORE
THROUGH TIME
Geoffrey Hewlett

With best wishes

Geoffrey Hewlett

AMBERLEY PUBLISHING

About the Author

The author has lived in the suburbs of north-west London since the age of two and has recently retired after forty years as a town planner in Local Government. Drawing on his local knowledge, *Kingsbury Through Time* was published in 2010 and *Welsh Harp Reservoir Through Time* followed in 2011.

This publication on Stanmore contains knowledge collected by the author over thirty years and builds on the rich archival resource that Harrow Council maintains. The author is particularly grateful for the access to and use of the Council's archives; without such consent this publication would not be possible.

Sincere thanks are also due to the author's wife, Susan, for recording views as they are now and for the support and cooperation received from council members, schools and churches, businesses and house owners and a number of experts in their field who have searched through documents and deeds. All have helped to provide a picture as accurate as possible of how the township of Stanmore we know today evolved.

First published 2012

Amberley Publishing
The Hill, Stroud
Gloucestershire, GL5 4EP

www.amberley-books.com

Copyright © Geoffrey Hewlett, 2012

The right of Geoffrey Hewlett to be identified as the Author of this work has been asserted in accordance with the Copyrights, Designs and Patents Act 1988.

ISBN 978 1 4456 0542 5

British Library Cataloguing in Publication Data.
A catalogue record for this book is available from the British Library.

Typeset in 9.5pt on 12pt Celeste.
Typesetting by Amberley Publishing.
Printed in the UK.

Introduction

Stanmore lies on the edge of north-west London. It was once in the County of Middlesex, but is now in the Borough of Harrow and is part of Greater London. Its name is a collective name for Great Stanmore (or Stanmore Magna), together with Little Stanmore (or Stanmore Parva, or Whitchurch). It may be that, to the non-historian today, such subtle distinctions pass us by, but they were relevant once in explaining the different ways in which the town developed. For the purposes of this study, Stanmore is being considered as Great Stanmore, an area that stretches from Belmont to Bentley Priory, and from Bromefield to Brockley Hill.

As long ago as 1720, Daniel Defoe commented on the charm of this select area and it is not without that charm today.

The earliest evidence of settlement in Stanmore is to be found on Brockley Hill. From here, the Roman Road out of London followed its surveyed course to Saint Alban's (for the most part called the 'A5') and on to North Wales. At Brockley Hill a pottery industry was established in the early AD 50s, barely ten years after the Roman invasion, during which the road, known as Watling Street, was also being built. Of the road itself there is surprisingly little hard evidence of its structure apart from its straightness. It did, though, provide access for the military to reach areas where resistance was a continuing problem. The ponds on the hilltop above may have given the settlement its name, describing stones either beside or in the lake, and suggesting they were natural features or the remains of Roman buildings further along the ridge some 490 feet above sea level. In any case the mere or pond on Stanmore Common is still referred to as Caesar's pond.

The medieval village of Stanmore evolved at the base of the scarp and it was here that the first of Stanmore's three churches came to be built. The first church was built in late Saxon or early medieval times near what is now the junction of Wolverton Road with Old Church Lane. It was replaced by the now-ruined brick church in 1632, reflecting the shift in the village centre to the north. The red brick church was built by Sir John Wolstenholme, a merchant adventurer who helped finance the exploration of northern Canada in the early 1600s.

In 1991, it was during repair works to the building that the coffin of the 4th Earl of Aberdeen, interred here in 1860, was rediscovered. The opening of the church took place in 1850. The Earl of Aberdeen who had been Colonial Secretary and Prime Minister gave £2,000 towards the £8,000 building fund.

Stanmore's name was most likely first recorded in the time of King Offa. His reign as Saxon King of Mercia (757–796) saw Mercian supremacy extend over much of south-east England. The word is used in AD 793, but it also appears later in the Domesday Book of 1086 when Stanmore was heavily wooded. It is likely that the medieval village was sited to the south near an earlier church.

Excavations at RAF Stanmore Park in 2000/01 revealed evidence of occupation from as early as the thirteenth century with ditches, footings, pots and pits. There were signs of building from 1475 to 1625 and later still, in the early eighteenth century, prior to the construction of Stanmore Park in the 1760s. The most significant change in the nineteenth century came with the arrival of wealthy residents who sought charm and seclusion, like Charles Fortnum of Fortnum & Mason, Robert Hollond, Knox D'Arcy, Queen Adelaide, Thomas Clutterbuck and the man who came to own half of Stanmore, Frederick Gordon. William Morris considered Stanmore to be 'pretty after a fashion, very well wooded and beset with gentlemen's houses'. In 1932, the *Ideal Homes* estate brochure saw it as being 'just far enough out of London to have a distinct life of its own' – and *Stanmore Through Time* recalls the circumstances of just how this came about.

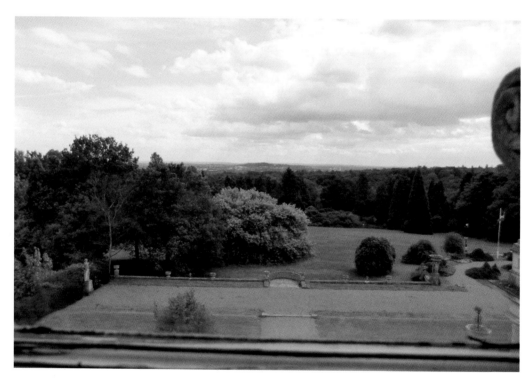

View across London from rear of Bentley Priory (*Tony Wood*)
'Well wooded slopes facing London, beset with gentlemen's houses.'

The Changing Face of a Village

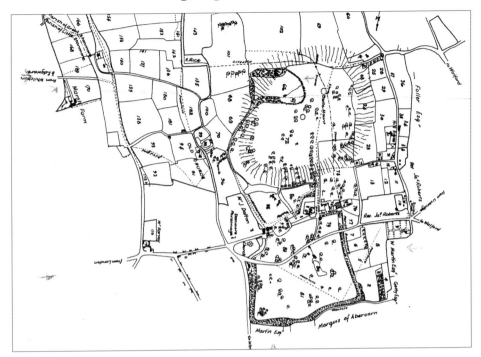

Stanmore Tithe Award Map, 1838

The old Stanmore Tithe Award Map of 1838 shows the location of the original church, a tomb, the old lanes and the farms. Roman finds at Brockley indicate the site was occupied up to the end of the fourth century. Nothing of similar antiquity exists for what we would describe as Stanmore. Grants of land and charters exist from AD 793 and there are references to the two parts of Stanmore in the Domesday Book in 1086.

The population at that time comprised thirteen resident heads of households, which would be equivalent to fifty-eight people. Its medieval development appears to have been centred on a manor house with a moat, built in the mid-thirteenth century. By 1350, there was a church dedicated to St Mary on the north side of Wolverton Road, as shown on the extract above.

Then, for whatever reason (and the Black Death of 1349 is often a good contender) residents left the old village and found a new settlement to the north, away from its earlier site, with a new manor house on the east side of Old Church Lane, and a new brick church of St John built in 1632 to supersede the medieval one. Foundations of the medieval parish church were uncovered when the Stanmore railway was being built in 1889. Further evidence came to light when the houses were under construction in Old Church Lane in 1892. A tomb stone of the first medieval church of Stanmore survives in the rear garden of 44 Old Church Lane.

In assessing the extent of Stanmore's expansion over a period of time, it is necessary to ask what critical events have influenced change and what was the form or shape of the village at a particular date. To paint a picture of what life was like, there are alternatives to photographs or census returns. Parish records of population growth, assessment of age of buildings, archaeological excavation and maps are all potential sources. Piecing together information on the expansion of towns required improvements in mapping techniques so that details of topography and the extent of village sprawl could be assessed. The following is an example of this.

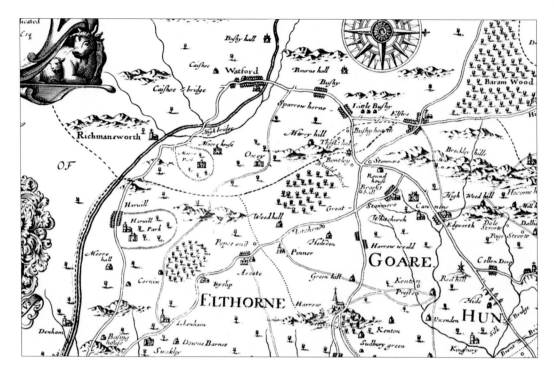

J. Ogilby's Map of Middlesex (1672)

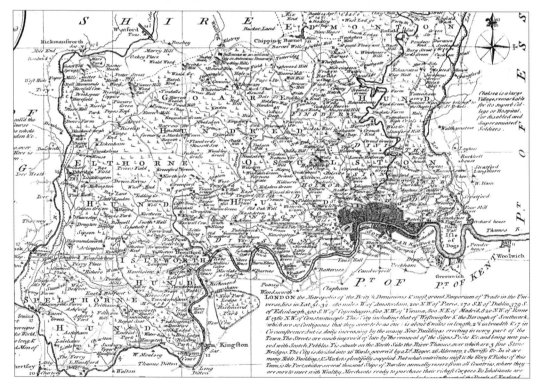

R. Morden's Map of 1695

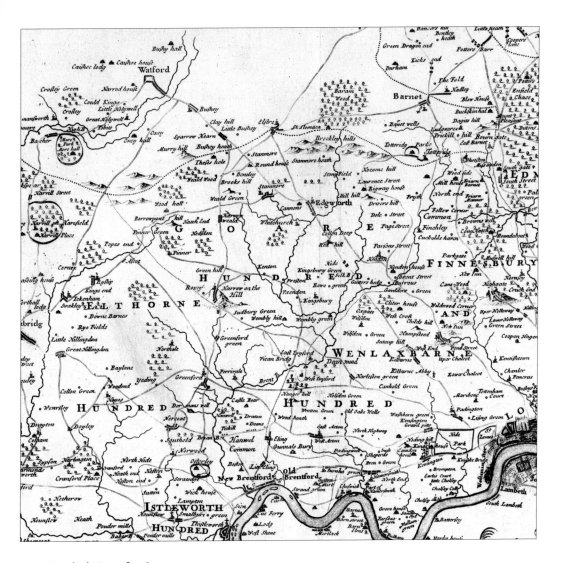

Bowles' Map of 1785

John Ogilby's Map of Middlesex (1672) can be compared with Robert Morden's Map of 1695, and Bowles' of 1785. Such maps merely showed the relative proximity of places, not the extent of towns or how to get to them. On the other hand, Ogilby (1600–1676) did introduce a route guide to aid the traveller. Similar guides called *Paterson's Roads* published by Edward Mogg from at least 1811 until 1826 had been printed by John Cary (*c.* 1754–1835) in the years 1785–1810 and were not that dissimilar to those first produced by the AA in the 1960s. In the sixty years after Bowles, travel and business would have been encouraged by, among other matters, the accuracy and reliability of maps. In addition, map makers were improving their local content; Warburton's Map of Middlesex (1749), for example, identifies a religious house and Roman station on Brockley Hill along with a growing centre of Stanmore. Bowles' map of 1785 shows Sulloniacae as an ancient city; with Stanmore possessing a rectory and modern charity school.

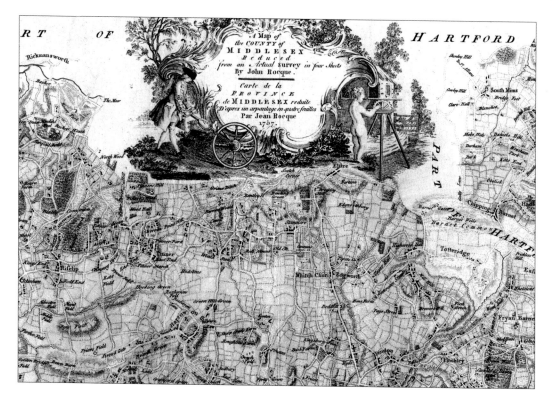

J. Rocque

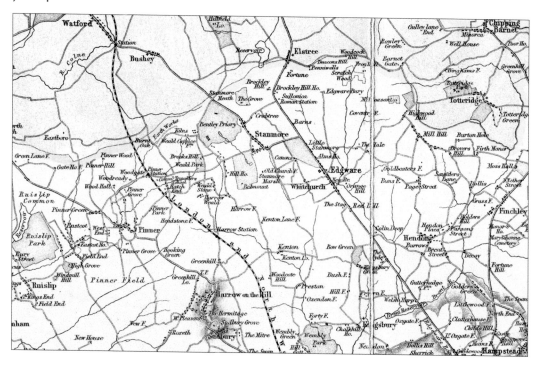

Bartholomew, Nineteenth Century

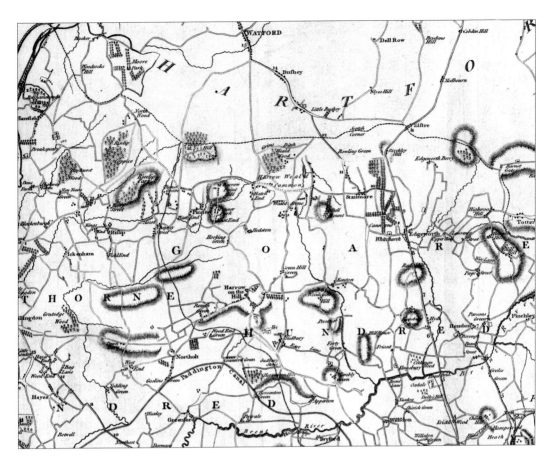

J. Cary

The time of John Rocque (*c.* 1709–1762) heralded a new era of map making previously dominated by large scale maps. Comparing it with Rocque's style (1757) and John Cary's (1805), Bartholomew's map of *c.* 1850 perhaps shows the growing influence of communication and of the Ordnance Survey, which was established in 1791 after the complete mapping of Scotland in response to the threat being posed by a Napoleonic invasion. The first detailed edition of the Ordnance Survey to a scale of one inch to the mile was issued in 1801/1805 and maps to a scale of 1:2500 appeared county by county from 1854.

These maps are very similar to Johnson's map for the post office of 1874. The slopes of Stanmore Hill were attractive for their stylish eighteenth- and nineteenth-century buildings, which together with the woodland around Stanmore Common provided a setting for even grander and later architectural gems. In 1801, the population of Great Stanmore parish was 722 and was relatively static between 1841 and 1891, with a population of 1473. However, by 1951 numbers had reached over 17,000.

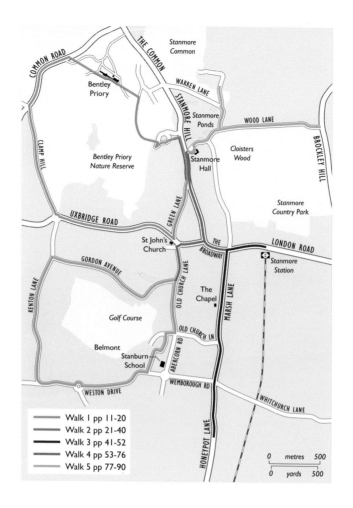

Map legend:
- Walk 1 pp 11-20
- Walk 2 pp 21-40
- Walk 3 pp 41-52
- Walk 4 pp 53-76
- Walk 5 pp 77-90

Excavations have shown buildings in the thirteenth and sixteenth centuries not only at Stanmore Park but also at Stanmore Hill, Green Lane and Church Road, where Regent House had already stood since 1470 – a century older than the timber cottages in the Broadway, which appeared *c.* 1565, and much older than the brick church of 1632. There were buildings in 1710, if not earlier, where Barclay's bank now exists.

Overall, the settlement lacked the kind of villas that the Victorian age would bring; the dwellings of the 'well-to-do' were yet to come.

Like many suburbs of London, Stanmore expanded in response to improvements in public transport. Settlement growth was slow, but at some critical point in the eighteenth century Stanmore began to attract those who sought seclusion or privacy, where the village character was much to their liking. From resident Monarchs, Lords and Earls to founders of retail companies and hotel chains, Stanmore's way of life became more affluent and featured. Village life survived even until the 1950s and the station was re-named Stanmore Village reflecting that change.

Stanmore is not like every other centre. The golf course, the nature reserves and animals, and the green belt and horse riding have all survived with top secret government installations – and alongside the hustle and bustle of the High Street.

The following sections look at the stresses and threats to existing buildings which have eroded over time. The area for this purpose has been subdivided into five geographical districts: West; South; East; Central and North. (*Map produced by Latitude Mapping Ltd*).

Stanmore's Western Edge

The western boundary of Stanmore follows the line of the Bentley Priory estate and abuts Harrow Weald leaving it outside this narrative. This commentary begins by describing a route, which starts from the parish church on the western edge of Stanmore.

From Green Lane to Bentley and Heriots

The church of St John was built in 1849–50 and is a prominent building in the street scene close to Green Lane, one of Stanmore's oldest roads. A walk along Green Lane reveals a mix of house styles and ages typical of suburbia. The last houses at the top of the road date from 1957 and some at the bottom are even more recent. The first house of interest at the bottom of the lane is the red-brick gable lodge to the Pynnacles, near where Cherchefelle Mews was built in 1989. Next is Rylands, which is seventeenth-century in part; as is the Olde Cottage beside it. On the incline, terraces of well-kept Georgian cottages provide charm and character in an otherwise modern suburban setting. Pinnacle Place and Park Cottages at the northern end of the road date back to about 1780–1820 and possess detailing typical of the period – sash windows and decorative fanlights, as at Park House.

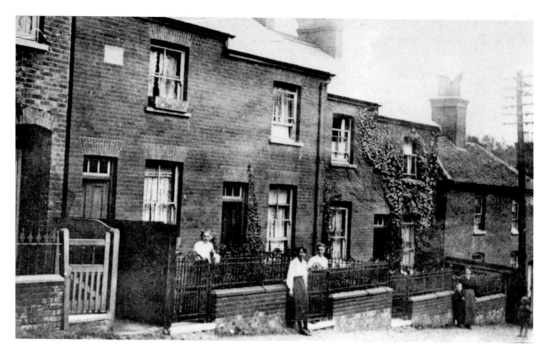

Hillcrest and Chart Cottages

Situated on the east side, these represent a more recent and simpler house style of the Edwardian decade. Chart Cottages are dated 1903 and are complemented by Green Lane Cottages on the west side. Half brick and timber, red or London stock brick and horizontal boarding all contribute to the domestic character. Beyond Franklin Cottages, on the east side, the houses are set back further and the larger gardens reflect a more recent date of construction. The houses and nineteenth-century maps together show the degree of expansion, however limited, which took place. The development here is of some intensity, with cottages built to the back edge of pavement and others provided with pretty front gardens. The demolition of the larger properties on the west has prevented crowding and has maintained an open vista.

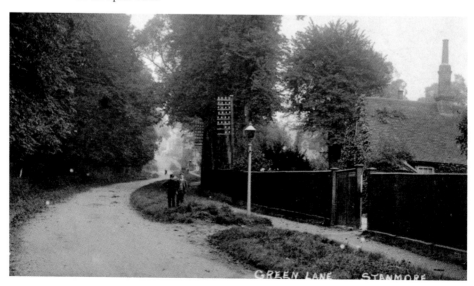

GREEN LANE STANMORE

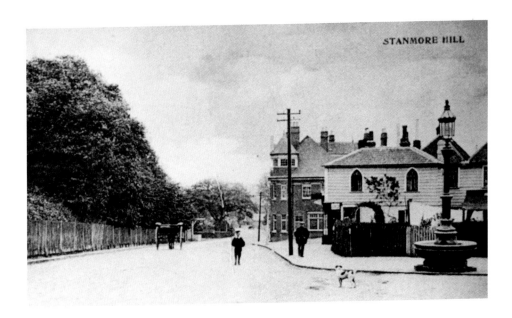

Drinking Fountain

At the bottom of Green Lane, beside St John's Church stands the base of the drinking fountain, which had previously stood at the top of Stanmore Hill. The fountain had been provided by Sister Agnes Keyser of Warren House, founder of King Edward VII Hospital in St Marylebone for officers wounded in the Boer War. Her brother Charles Edward Keyser (*see page 91*) was a founder member and first chairman of the Colne Valley Water Company who was instrumental in purifying drinking water and thereby eradicating typhoid, epidemics of which swept London in the 1860s.

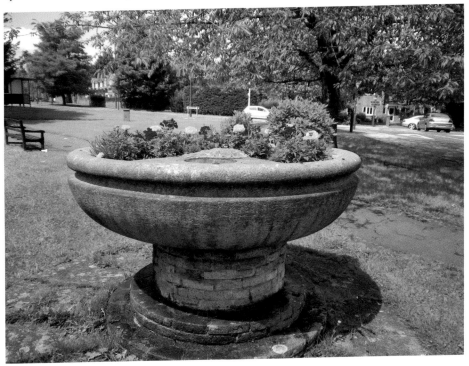

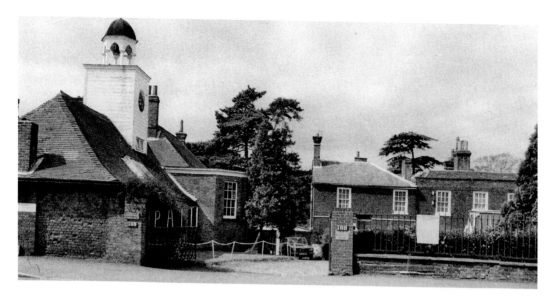

The Brewer's House

Thomas Clutterbuck bought the Vine public house in 1762 and in 1763 he acquired the brewery as well, apparently for his son Thomas (1744–1791), in partnership with Thomas Meadows. The 'Peter Clutterbucks', father and son, (1749–1814) and (1782–1837) and Thomas Clutterbuck (1808–1898) continued the family tradition. In 1851, the brewery was employing thirty men and when Thomas Meadows Clutterbuck died in 1919 he left nearly £411,000 in his will. When brewing stopped in Stanmore in 1916, the main building became a bottle store. The brewery was acquired by the Cannon Brewery in 1923. The granary was demolished in 1988 to enable Charles Church Estates to develop the site as apartments while retaining the brewery building. Aylmer Drive and Aylwards Close were built on the west side of Stanmore Hill on the site of the house and gardens of Aylwards, which was demolished around 1934.

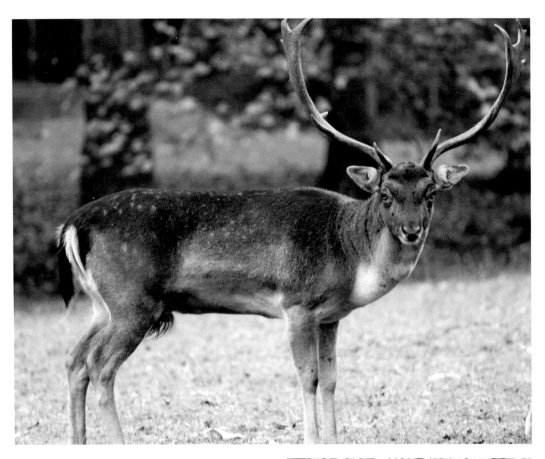

Bentley Priory Nature Reserve & Deer Park
The Nature Reserve comprises 87 hectares of woodland and open grass habitats, which are of scientific interest. Footpath access from the south progresses uphill through Heriots Wood, which pre-dates 1600. On the upward path a resident herd of deer is a visitor attraction. The house named Heriots was built on the edge of the Bentley Priory estate in 1925. It was then that the herd of deer at Heriots was established by Mrs Arthur, who brought them from Ashridge Park. She lived at the Pynnacles on the corner of Green Lane until it was destroyed by fire in 1930 and sold in 1932. The transfer was organised by Captain Younghusband and, in 1933, Brigadier Ralph Micklem (1884–1977) bought Heriots. The present owner bought the property in 2005 and currently there are thirty-one fallow deer of mixed age and sex. The house itself was occupied by the President of Poland in 1942–1945.

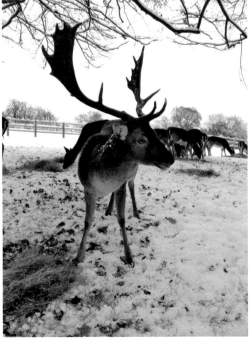

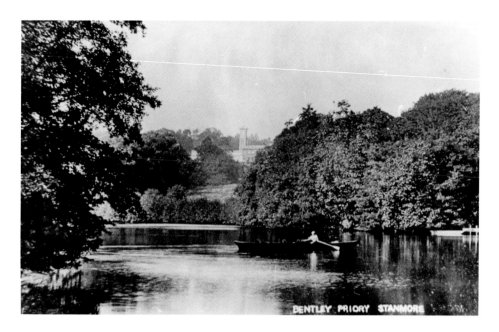

Bentley Priory

The name of Bentley Priory is recorded as *Benetlegh* as early as 1243, meaning woodland pasture with bent grass. The name was given to this site where an Augustinian priory had been founded at some time between 1170 and 1243, and given with its lands to the Prior of St Gregory's at Canterbury. It is likely that the Priory had ceased by the time of the Dissolution in the 1530s and its history thereafter is somewhat obscure. Lower Priory Farm, off Clamp Hill, is probably close to where the Priory Chapel used to be. An earlier building near the site was sold to an Army contractor, James Duberly about 1766, which he demolished and then rebuilt in a style that was to form the basis of Bentley Priory. On the completion of Bentley Priory in 1788, the estate was sold.

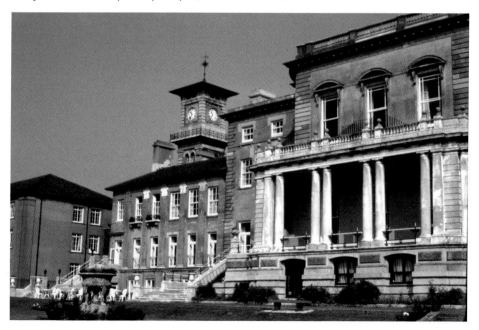

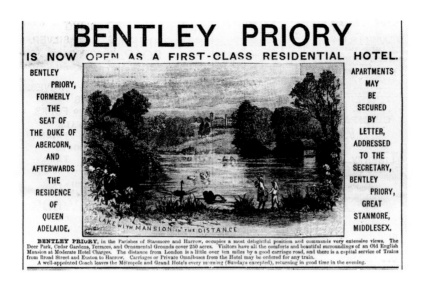

BENTLEY PRIORY
IS NOW OPEN AS A FIRST-CLASS RESIDENTIAL HOTEL.

BENTLEY PRIORY, FORMERLY THE SEAT OF THE DUKE OF ABERCORN, AND AFTERWARDS THE RESIDENCE OF QUEEN ADELAIDE.

LAKE WITH MANSION IN THE DISTANCE.

APARTMENTS MAY BE SECURED BY LETTER, ADDRESSED TO THE SECRETARY, BENTLEY PRIORY, GREAT STANMORE, MIDDLESEX.

BENTLEY PRIORY, in the Parishes of Stanmore and Harrow, occupies a most delightful position and commands very extensive views. The Deer Park, Cedar Gardens, Terraces, and Ornamental Grounds cover 250 acres. Visitors have all the comforts and beautiful surroundings of an Old English Mansion at Moderate Hotel Charges. The distance from London is a little over ten miles by a good carriage road, and there is a capital service of Trains from Broad Street and Euston to Harrow. Carriages or Private Omnibuses from the Hotel may be ordered for any train. A well-appointed Coach leaves the Métropole and Grand Hotels every morning (Sundays excepted), returning in good time in the evening.

Bentley Priory

Bentley Priory was re-modelled in 1789–1798 by the architect Sir John Soane for Sir John James Hamilton (*see page 91*), the First Marquess of Abercorn (1756–1818). He died leaving it to his grandson who became the first Duke of Abercorn in 1868. As the Second Marquess, he let the premises to raise money and Queen Adelaide (*see page 90*) leased it from 1846 and stayed here from 1848, already seriously ill with dropsy. She had been advised that the Stanmore air was 'salubrious', but she died here on 2 December 1849. Land sales saved him from financial ruin and from 1863 the Priory was the home of Sir John Kelk (1816–1886; *see page 91*), a self made civil engineering and railway contractor and JP for Middlesex. In 1880, the Priory was put up for sale and, by 1882, Kelk had sold it to Frederick Gordon (1835–1904; *see page 93*). From 1885 Gordon ran it as a luxury country hotel while his own family lived in a house he built in the grounds. The failure of his hotel plans in 1891 led him to occupy the Priory himself. Following Gordon's death his vast estate was sold at auction. The Priory was sold for use as a Girls' School from 1908 until it closed in 1922. The property stayed vacant until March 1926 when it was bought by the Air Ministry to become the headquarters of Fighter Command in 1936. Dowding's room is restored below.

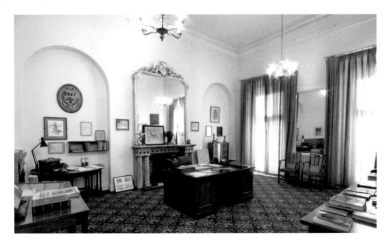

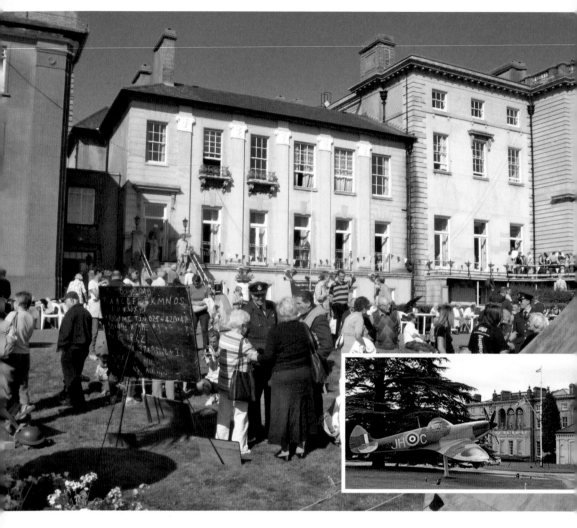

Bentley Priory

From Bentley Priory, Lord Dowding controlled RAF operations during the Battle of Britain in 1940. Sir Hugh Dowding (1882–1970) took the title of Baron Dowding of Bentley Priory in 1943. The building was restored following an extensive fire in June 1979. In 2008 the RAF base closed, and planning permission and listed building consent were obtained for over 100 residential units. New homes would be built by Barratt North London together with a Battle of Britain museum. The scheme includes the conversion of the Priory and two other listed buildings into twenty-five converted homes by 'City and Country'. The architects are Robert Adams for planning and Purcell Miller Tritton and Exposito Mclean for each of the two phases of the Priory's conversion. The scheme is supported by the Heritage Lottery Fund and the Bentley Priory Battle of Britain Trust. The museum is due to be opened in 2013.

Clamp Hill and Common Road

Developments along Clamp Hill and Common Road retain an attractive woodland frontage which screens a number of community uses. The Princess Alexandra Home in Common Road is one such an example. Built about 1887, its 16-acre grounds were created out of the Bentley Priory estate for a proposed hotel. Until at least 1914 it was called 'The Holt' and by 1934 'Disley Close'. The premises were used as a private residence until a former Mayor of Wembley, Sydney Newland, acquired it for use as a residential home from Harold Bolman in 1951. From 1952 it was run by Wembley Eventide Homes and in 2002, the home was taken over by Jewish Care, providing a sixty-eight-bed care home for nursing the elderly. The Hermitage lay south of Priory Farm, which was demolished in the 1930s. The former lodge to the Hermitage, Hermitage Gate, has survived the changes that have gone on around it. Heriots Wood Grammar School for girls, opened in 1956, became Bentley Wood High School in September 1974.

Housing Developments

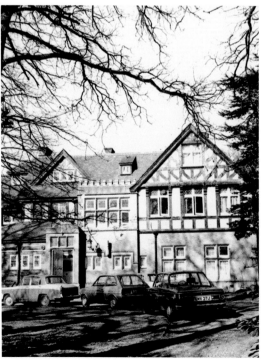

Large Victorian houses in substantial grounds were once common place, but their demolition released land for housing. The names of un-numbered houses, like Bowls or Dearne, Ben Hale or Culverlands, were retained as part of the address of the cul-de-sac. Dearne Close, seen here, began as an extensive property at 22 Uxbridge Road and was demolished to make way for flats in 1999, keeping the original house name. Similarly, Bowls Close was derived from a house called 'Bowls', which was built on part of the Bentley Priory estate. Designed by Arnold Mitchell between 1893 and '96, in typical Arts & Crafts style it was demolished in 1962 to make way for houses built in 1964. Of the early lodge houses on the Bentley Estate there are examples in Uxbridge Road like Old Lodge Way with its elaborate architectural detailing. Bentley Way was also carved out of the Bentley estate and provided a green field site developed by Coopers in 1936.

Stanmore's Southern Boundary

From Kenton Lane to Belmont and Stanburn

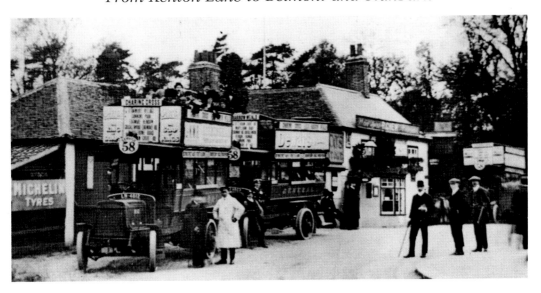

Seven Balls

The Seven Balls in Kenton Lane is a timber framed public house dating back to the seventeenth century. It once boasted a bus service from here to Charing Cross. Diagonally opposite was the Hill House estate, which formed part of Stanmore Park. Sections were sold off over time and it wasn't until the 1920s that Hill House itself was demolished to make way for Trevor Close. The Grimsdyke service station, which lies opposite, was the site of allotments during the war, but after that sold petrol. The premises held an Esso station run by the Walker family until 1963 when the present family business took over. They bought the freehold in 1986 and now operate a car sales and repair business. Gordon Avenue is of mixed age from the early eighteenth-century terrace of cottages at Nos. 124–130, to the Arts & Crafts of the 1890s, to modern development schemes. Kenton Lane and its hinterland keeps its suburban character of 1928–34. Below, is the Duck in the Pond.

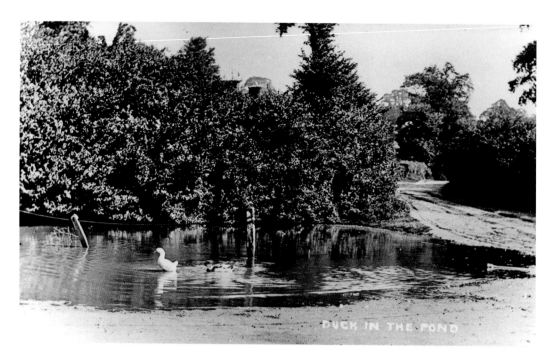

The Duck in the Pond

The Duck in the Pond was once a single storey, timber clad building, described as a beer house in 1852. Judging by its appearance, it was rebuilt and enlarged in the 1920s/30s. Opposite, across the road junction, was the Rose & Crown formerly Rose Farm, which was demolished around 1931 and its spirit licence was transferred to the Duck in the Pond.

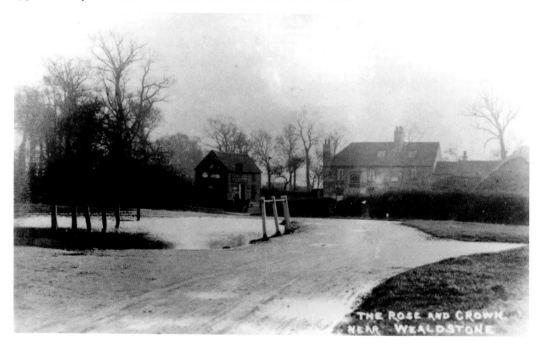

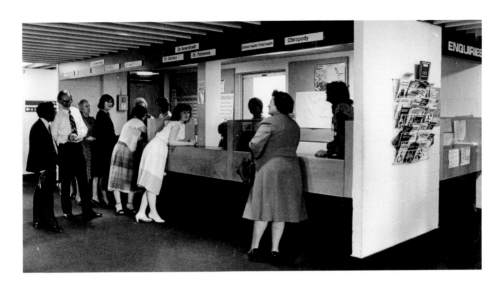

The Belmont Health Centre

The rapid growth of housing throughout the suburbs placed immense strains on all public services including worship and the health service. The story of Belmont Health Centre is typical of many in the way it has adapted to population growth, the way it has taken on new functions like minor operations and how it has taken on a greater role in preventative medicine. At a time when Belmont was growing rapidly there were a number of individual GP practices working from cramped converted houses. As an example, in 1935 Dr Joseph Gordon ran his surgery from 522, Kenton Lane on the edge of the fast growing Davis estate. Within a radius of a mile (1.5 km) there were five or six single-handed practices. As time passed, Gordon ran the morning surgery but took on from 1970 a consultant to run the evening surgery. The doctor who took on that role was Dr G. Pallawela, who was a cardiac thoracic specialist at Brook General Hospital, Woolwich.

A surgery nearby, opposite the clock tower in Wealdstone, was run by Dr Michael Winter. Dr Anthony Hand who was his second in command took charge on Winter's death and later led one of the practices at the health centre when it was set up. By the beginning of the 1970s doctors were seeking all-embracing health centres. There were no such centres in Harrow at that time, due in part to the cost of funding them and Belmont was apparently due to be the first. However, in this instance the doctors found an ally in Mr Madan, the administrator of the Local Family Practitioners Committee, who supported an integrated approach. In some cases, despite house prices of £450, builders offered or allocated space for surgeries. It was fortunate for Belmont that a site was identified early on in Kenton Lane, which was a garden centre in Council ownership. While that was ultimately the site selected, it did meet with some strenuous objection, particularly from Dr Gordon. Building works began in 1976 and the centre in Kenton Lane was available for occupation in September 1978.

Death or retirement has since reshaped the groups, but broadly three practices operate from the centre today with increased patient lists: Dr Pallawela succeeded the late Dr Gordon and in his own retirement his previous team has now six doctors headed by Dr J. J. Wijeratne serving 12,000 patients; the Circle Practice – Dr Vyas and partners, which comprises four doctors (including Martin Adler who joined the practice in April 1984) serving 8,000/ 9,000 patients; and the Enterprise Practice – Dr Graham Sado and one partner, Dr Marion Allwright.

The roles of the family doctor have changed much in the twentieth century. These now include immunisation against and eradication of infectious diseases like mumps, cardiac monitoring and cancer screening, and initiatives aimed at prevention, including the reduction of strokes. Of particular note is the current size of patient lists and the impact this has on surgery management and of course on the doctors themselves.

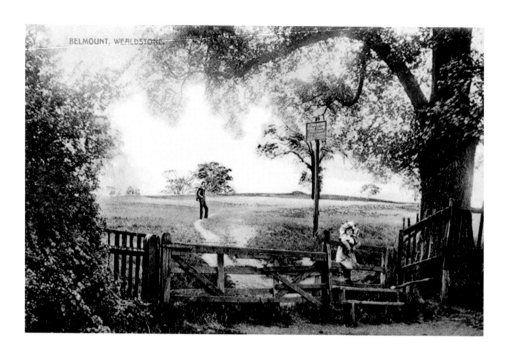

Belmont

The name of Belmont or *Bell Mount* was coined in the eighteenth century and appears on Rocque's maps of 1754 & 1757. The mound, which was manmade, remains in what is now Stanmore Golf Course. Before 1789, the hill was surmounted by Mr Drummond's summer house, which would have formed part of the estate's landscaping, the famed 'Chandos Vista', which the then first Duke of Chandos, Sir James Brydges (1674–1744), was able to enjoy. Some 200 years later, bylaw approval was given to plans for nine shops in Belmont Circle, submitted by Marshall and Tweedy in October 1934 and for a further fourteen shops in November 1935. The shop designs were typical of their time in terms of appearance and included a station and pub. The estate agent's, W. H. Blackler, was established in 1937 and remains to this day.

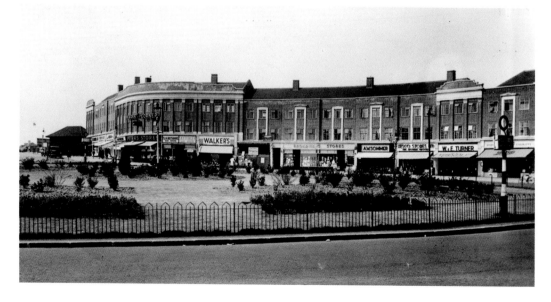

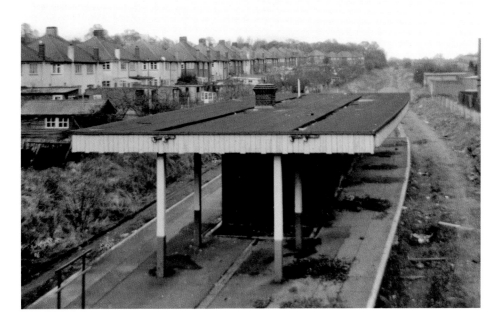

Belmont Station & Holt, 1966 (*J. E. Connor collection*)

The branch line from Harrow to Stanmore opened in December 1890. Belmont station appeared on this line as a single platform halt on 12 September 1932. Increases in commuter traffic called for better facilities so that the station was rebuilt as an island platform and given a passing loop before it was reopened on 5 July 1937. In time, customers used the bus service and the Metropolitan line, which opened to Stanmore station in 1932, providing a quicker service to the city. The 1950s saw the birth of car ownership for middle class families so that golf club users no longer required access by train. Passenger services beyond Belmont were ended on 15 September 1952, although a daily freight service operated to Stanmore until 6 July 1964. The station closed on 5 October 1964 and the buildings were demolished in July/August 1966, leaving a cleared site that is now a car park.

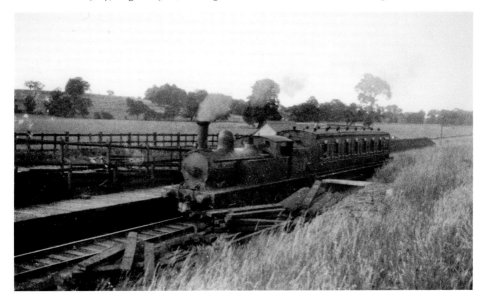

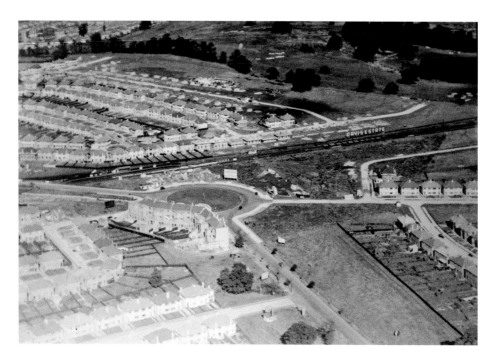

Belmont Station, 1935 & 1936

Belmont in September 1935 (*above*) and June 1936 (*below*); both images show the road layout. Plans for the Cannon Brewery's Belmont Hotel were approved in May 1935 and the public house has since changed its name firstly to the Spanish Arch and now to Funky Brownz and the Cardamom Restaurant. The Woolworth's store changed long since to become a petrol station, selling food for the engine and its driver. That other essential ingredient of the '30s, the cinema, closed for alterations and repairs in 1940. It reopened as the Plaza and then Essoldo in 1950. It was finally closed on 21 January 1967 and was reconfigured to become a Tesco.

St Anselms

The parish of Belmont was formed on 13 August 1940 out of the parishes of Greater Stanmore and Harrow Weald. The church was built as part of the initiative of moving city churches with dwindling congregations out to the suburbs where they were needed, in this case from the scale of St Anselms church in Davies Street, W1. The Dedication and opening service took place in the hall in November 1935, which had dual purpose use until the 'Basilican' style city church had been demolished and rebuilt by the architect Cachemaille-Day. Its foundation stone was laid in April 1940 and the building was consecrated on 17 May 1941. It was rare for a church to be built in wartime. The former hall was demolished and replaced by residentual units and a new hall, which was dedicated by the Bishop of Willesden 23 April 2005. The picture above the altar is considered to be early medieval whereas the picture of the Holy Family in the St Aidan's Chapel is the work of the seventeenth-century artist, José Ribera. Both of these went to Davies Street from Hanover Chapel in Regent Street when that was closed.

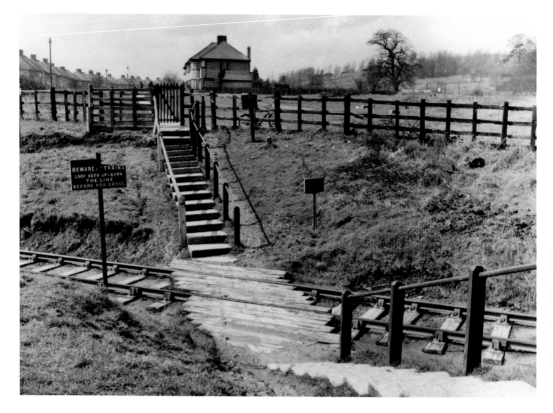

Impact of Wartime

The war interrupted the construction of Laing's estate as it progressed along Wemborough Road. Land had been allocated for housing back in December 1936, but the first houses in Honister Gardens were completed in 1954. By the end of 1955 house prices here had risen steeply from £330 to £2,750. It was intended to connect Vernon Drive to Wemborough Road, but construction was delayed by the need to build a railway bridge and by the outbreak of war. The Stanmore railway was closed to passengers in 1952 and the track was lifted in 1964. The fate of the road scheme was settled by the construction of houses across the link road in the early 1990s, which meant that residents could at last forget the prospects of heavy traffic cutting through their estate. The main road to Belmont has changed its course as well as its name, to Weston Drive, which Harding built in the 1930s.

Developers like John Laing imposed what is termed 'restrictive covenants' on their estates to protect the quality of what they had built and to safeguard the amenities of neighbours. Today such concerns are addressed through the planning system by Local Planning Authorities. Before the era of detailed planning controls, a typical set of covenants would have restricted house buyers in Honister Gardens in 1954 to: 1) No trade or business shall be carried on, but the premises shall be used only as a private dwellinghouse with or without a garage. 2) The boundary walls and fences between the premises shall be erected half on the land transferred and half on the adjoining sites and shall be treated as party walls and fences. Garden fences at the rear shall not exceed 6 feet in height and 3 feet in the front. The purchaser shall twice in every year and oftener if necessary trim privets and replant any that have died. If the purchaser desires to erect a garage he shall apply to the vendors for their consent. He shall also enter at reasonable times for the purpose of cleaning out gutters. 3) Purchaser to keep in good repair front hedges and fences and bush planted areas and grass margins neatly cut at least once in every fortnight during the summer. 4) No wireless or television mast be erected unless of a design first approved by vendor and not connected to any chimney but only to the fascia below the eaves.

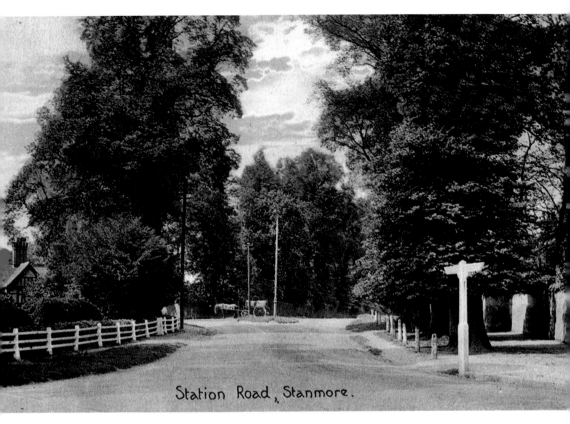

Station Road, Stanmore.

Belmont Lane

The lane was a country road called Watery Lane, which until about 1930 twisted and turned linking Honeypot Lane to Old Church Lane. One of the twists is perpetuated in the change in road name beside the Baptist church. Eventually, Belmont Lane was built giving better access to the housing with Gordon's Stuart cottages on one side and Clare's housing on the other. The curious property designs include the 'Quadrangle', which is U-shaped in form with a central courtyard. It was built in the late nineteenth century as a stabling block for horses belonging to Whiteley's, the London department store, aiding deliveries to Watford and beyond. It is now flats. Courtens Mews were named after a local garden centre, which previously occupied the mews site. Adjoining the 'Quadrangle' stands Aberdeen Cottages, another set piece in Arts & Crafts design with pargetted gables, dating 1901. Further south lays Oak Tree Close, sold by Stanmore Estates and built about 1923.

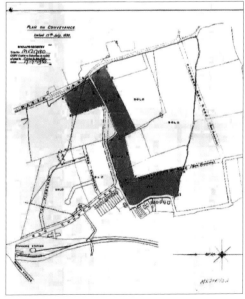

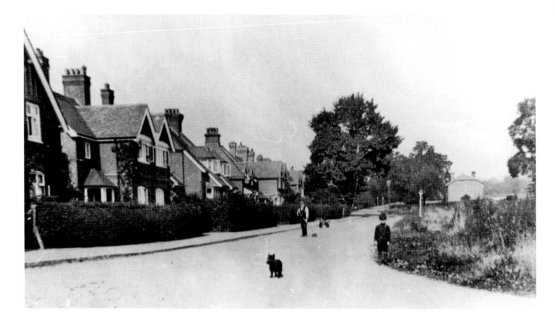

Housing in Old Church Lane

From the late 1920s to the mid-1930s the major landholders began to realise the potential residential land value of their investment. A significant part of southern Stanmore was owned by the 'Mayor, Commonality and Citizens of the City of London as Governors of the House of the Poor, commonly called St Bartholomew's Hospital'. Planning schemes were already in hand and the Governors of St Bartholomew's were selling land for housing to Clare's in Old Church Lane and Abercorn Road, where houses were completed by mid-1934. Additional land was sold to Clare by the Upcher family. The conveyance plan of 1930 showed the sharp bend that existed and still does in Old Church Lane, as well as its proposed continuation as Abercorn Road. Below is the site of Stanmore Baptist Church.

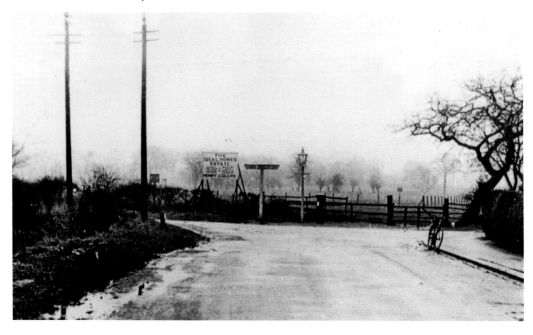

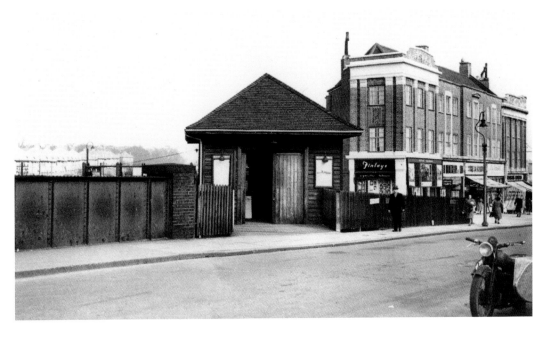

Railway

The Stanmore line was built by Braddocks of Wigan and opened as a branch line from Harrow & Wealdstone on 18 December 1890. The road to the station was renamed Station Road. A halt was opened at Belmont on 12 September 1932, and was later rebuilt as Belmont station. The house builders, Davis Estates Ltd, acquired their land on 7 December 1934 and houses were ready for occupation from March 1935. Belmont station closed in October 1964, twelve years after Stanmore Village station, but before the line was closed completely, a service to Belmont was provided by a diesel train affectionately known as the *Belmont Rattler*. The original character of Stanmore station was lost in rebuilding when the finer details of the stone entrance were removed and the old terminus was demolished in the 1970s for September Way. (*Photograph: Belmont Ticket Office, 1950. J. E. Conner collection*).

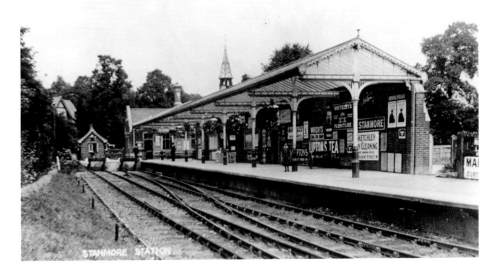

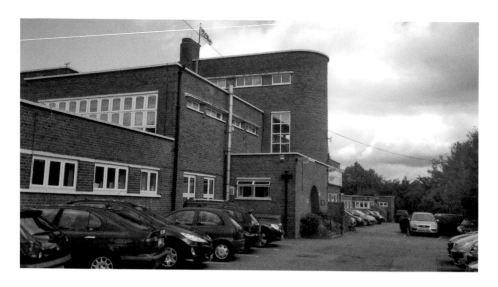

Stanburn Schools

In AD 978 the Edgware Brook, which flows by this site, was called the Stanburn or 'stony stream'. The schools began in the Baptist Church Hall when Ethel Mary Weedon opened a temporary school there on 30 March 1936. It then expanded into St Aidan's Hall in Uppingham Avenue in December 1937. The present Stanburn Schools were designed by Curtis & Burchett and opened with 278 children on the roll on 25 April 1938. Increased pupil numbers at First (4–7 years) and Primary (7–11 years) school levels are expected over the next five years. This suggests pupil numbers will reach 360 from 300 and 480 from 360, requiring the size of extension proposed in the early post-war years. War was declared on 3 September 1939 and air raid shelters were built in the following Christmas holiday. The worst local incident was in March 1945 when a V2 rocket hit a house in Uppingham Avenue, killing nine people. The school's blast shelter, which has been restored as a museum, was opened by Tony McNulty, MP, on 28 June 2008.

Stanmore Baptist Church

The first meeting of Stanmore Baptist Church attracted fourteen people. It was held in July 1935, firstly in the estate office of the local builder, Mr H. J. Clare, and thereafter in a converted barn. The first sod was cut at the meeting in November. The site of the present building was bought from Mr Clare for £800 and the building was completed at a cost of £2,250 and dedicated on 21 March 1936. The Girls' Brigade was founded in 1938 and the Boys' Brigade in 1958. A full-time minister needed a manse, which was built by Laings in 1949 on the last remaining plot in Belmont Lane and completed in December 1950 at a cost of £1,975. In 1961, a Children's Summer Mission (now called Holiday Club) was arranged for the first week of the school holidays and this annual event has continued. Playgroup and toddlers groups for the younger members and Missionary support, continues to flourish in this country and abroad.

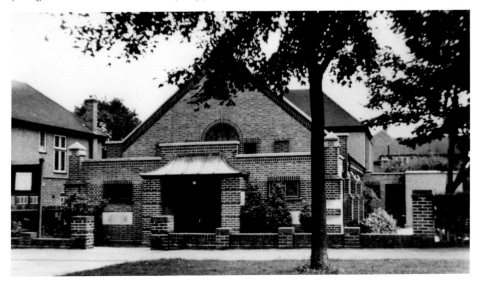

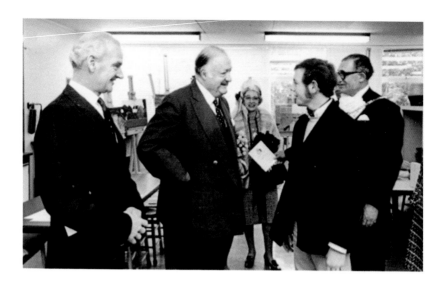

Stanmore College

A prep school called Alcuin House had existed between Old Church Lane and Lansdowne Road from the late 1940s until 1960, but it was Stanmore College that introduced college education here. Starting at a 550-capacity, Harrow Junior College in 1969 was formally opened by Lord (Rab) Butler in October 1970. Its name was changed in 1974 to Stanmore Sixth Form College before it became Elm Park Tertiary College in 1987. With colleges becoming independent of local authority control in April 1993 it became Stanmore College in 1994. It lost its funding for a complete rebuild in 2009 when its funding body, the National Learning and Skills Council, ran into difficulties. The College now has refurbished science laboratories and classrooms, along with a new teaching building, the Rowan building, seen here. It now accommodates 1,600 16–19–year–old full-time students and 3,000 adult part-timers on courses from performing arts to computing, and beauty to book keeping.

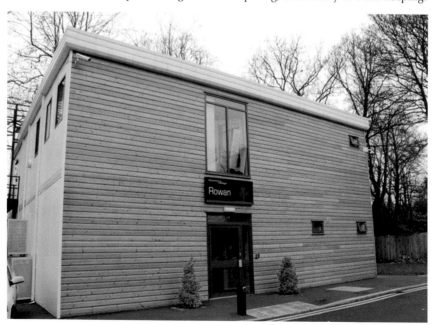

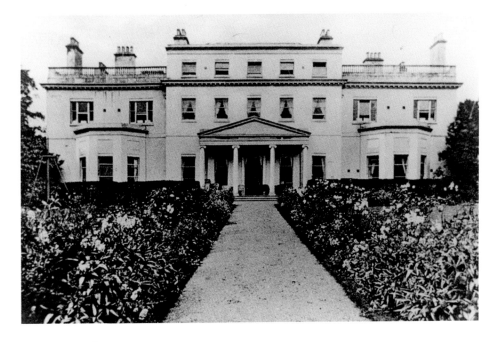

Stanmore Park

Andrew Drummond (1688–1769; *see page 90*) came to London to found Drummond's bank in 1717. By 1729, he had bought a house in Stanmore called Hodgkins. In 1763 he rebuilt it to match designs by John Vardy, which were completed by Sir William Chambers. It was named Stanmore Park. The later Drummonds were gamblers and spendthrifts and their estate had to be leased out or sold to pay debts. George Drummond for example left debts of £141,000 when he died in 1789. The 4th Countess Aylesford (*see page 90*) was resident there in 1815 and the Marquess of Abercorn finally bought the estate in 1839. It was next bought at auction in 1848 by George Carr Glyn, a partner in a banking firm who became Lord Wolverton in 1869 and Chairman of the London & North Western Railway. He was succeeded in 1873 by his son, who sold the estate to Frederick Gordon in March 1887.

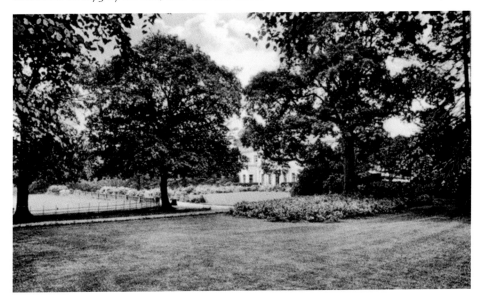

Temple Pond

The mansion house became a boys' preparatory school in 1887–1900 under Mr H. Kemball Cook and continued under England Cricketer Reverend Vernon Peter Fanshawe Royle who ran the school in 1900–1929. In June 1938 it was acquired by the RAF and demolished by them in 1938 to make way for a barrage balloon unit. At some time in or after 1789, the Countess Aylesford sought advice from the landscape architect, Humphry Repton, as to how best to landscape the grounds. A contemporary painting shows an ornamental lake and a temple in the garden, which are characteristic features of a Repton landscape. It is uncertain whether the pond was named after such a feature or after the Earl Temple (Earl 1753–1813) who was related by marriage to the Grenville family.

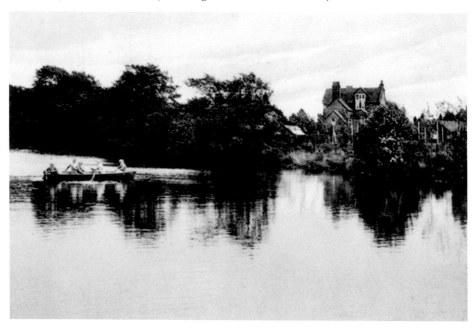

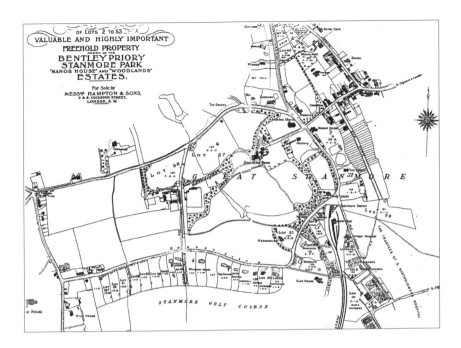

Land Sales

By the time Frederick Gordon (*see page 93*) had acquired Bentley Priory and Stanmore Park, laid out a golf course and built a railway as well, his land ownership was said to have covered half the parish. He built houses for his employees around 1890 in a distinctive Arts & Crafts design at Old Church Lane and Gordon Avenue. The cost of the cottage hospital, which opened in 1891, was met by the Wickens' sisters. Its service became attached to Edgware in 1971 but closed in 1980 to provide residential care. Gordon's untimely death in 1904 set in motion the dispersal of his estates, which were held in trust for his children by the Stanmore Estates Ltd. House building, which included Glenthorn where the Gordons lived, was limited. The plots were auctioned in 1909, but this was not a success either. With only a handful of plots sold in 1920–21, the estate company retained freeholds until 1953.

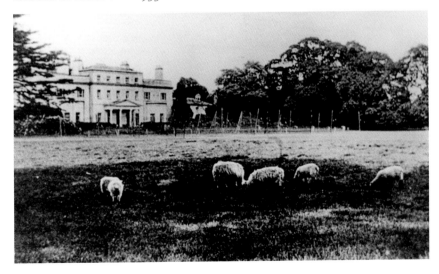

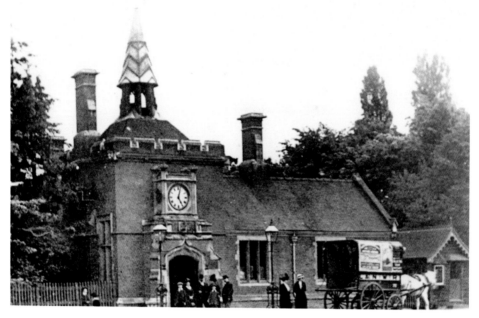

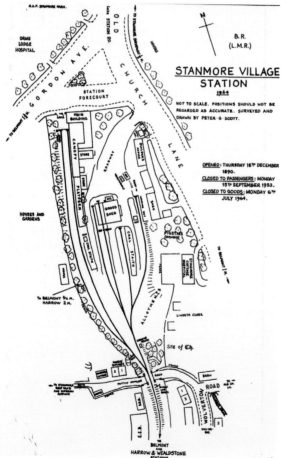

Stanmore Station

Land closest to Stanmore Station (re-named Stanmore Village Station in 1950) was developed to house railway staff, and with the opening of the terminus at Stanmore in 1890 Gordon proposed villas along a road to be named Gordon Avenue, after him. The railway branch line was built by Gordon to link his estates with the main line at Harrow & Wealdstone for members to travel to the golf club from London. Most of those villas have since been replaced by denser forms of development but the Arts & Crafts design of Herondale, by Waterhouse in 1891/92 still survives at 26/28 Gordon Avenue and shows a style he used for his later houses. A layout plan of 1921 shows Herondale in Gordon Avenue along with houses named Montrose and Rosslyn on one side of the access to the golf course and Westfield, Lynbrook and Link House on the other.

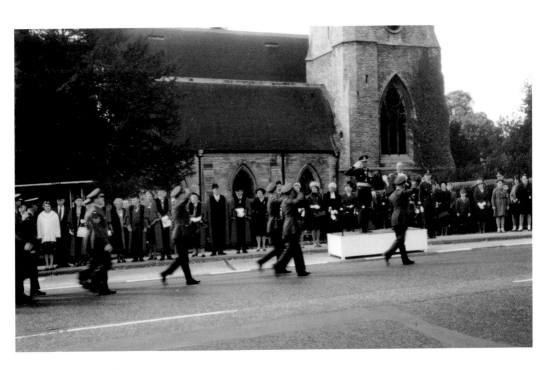

Stanmore Park

While the RAF maintained a presence at Stanmore Park it was able to use the base as a venue for related events. The impact of the closure of the RAF base in April 1997 meant that the regular march past 'Battle of Britain' memorial and Stanmore carnival assembly point all had to find alternative accommodation. The site was finally sold for housing development to John Laing and Bellway Homes in 2001–2003. Road names such as Lady Aylesford Avenue reflect its history. In the photograph above, the RAF Fighter Command salute.

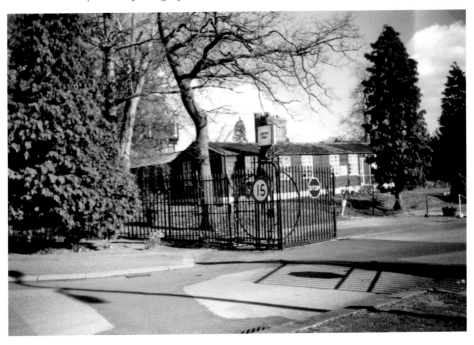

Stanmore Golf Club

Gordon had an elite circle of friends, including lawyers, city brokers and MPs. The golf club, which he founded in 1893, has an active membership today in excess of 500. All that remains now of the original Stanmore Park estate are the nineteenth-century gate piers next to the church lodge on Uxbridge Road and another set in Gordon Avenue. Its grounds include Stanmore golf course with a 'belmount' – a mound which provides a focal point for the view from Canons in what was a classical landscape of the time. Thomas Francis Blackwell was the co-sponsor of the club and its first president. His father had founded the renowned partnership of Crosse & Blackwel with Edmund Crosse.

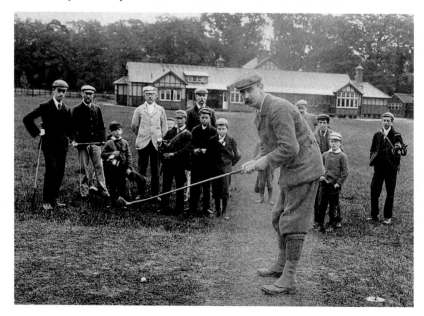

Along Stanmore's Eastern Edge

From Honeypot Lane to Stanmore Station

Honeypot Lane

This lane was a mud track of some antiquity. It was rebuilt in the early 1930s as a dual carriageway, when arterial roads were all the fashion. From the hill top to the south it descended to cross Whitchurch Lane at Stanmore Marsh. On the southern boundary stood the Green Man beer shop. This had appeared by 1851, but was demolished to make way for Amber House, a block of flats, in 2004. The 25-acre pitch was purchased as playing fields in 1930 and 1934, by which time a parade of shops had appeared at the road junction. Stanmore Library opened in 1949 on the first floor of a detached building where the ground floor was used as a clinic. The parade, which includes a chemist, grocer and launderette, continues to meet local needs and once for many years included a retailer of ice cream. The 12-acre site opposite was used as government offices for a number of departments, including the Department of Transport (DVLA). The search by London Boroughs in the 1990s for housing sites led to the scheme being built by St Edward in 2010–2012. Named Stanmore Place, it provides nearly 800 bedroom apartments, and business and retail units in an attractively landscape setting.

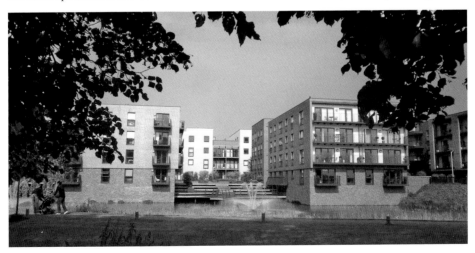

Stanmore Marsh

The marsh is an apt name for the fields either side of the Edgware Brook from Abercorn Road to the cross roads at Whitchurch Lane and Marsh Lane. Flood alleviation works have reduced the rise of water levels experienced and their regularity that occurred in the 1980s. Prior to this, and in earlier centuries, the flooding of farmland here must have been all too common, hence the name which appears on Rocque's map of 1757 and in earlier Court documents. Marsh Farm house was built in 1875 and was last farmed by the Bransgrove family until it became their private residence. During wartime, in the 1940s the farmhouse was used as a community facility. It was finally demolished and replaced by houses at 52a and 52b Bush Grove (*below*).

Whitchurch Fields & Schools

Whitchurch Playing Fields on the north side of Wemborough Road were once part of Marsh Farm and comprised grazing land until it was acquired in 1928 by Carreras as a company sports ground. It was then left to the Middlesex County Council to use its powers of compulsory purchase to acquire the land as school playing fields in 1961. Over thirty years later, on-site schooling facilities arrived and the Whitchurch First School opened in September 1992 and the Middle School in 1996. Further flood defence works were due to be carried out in 2012/2013 to protect the corridor of the Edgware Brook and to repair and re-grade the banks. Some of the willows obstructing the water course have been removed.

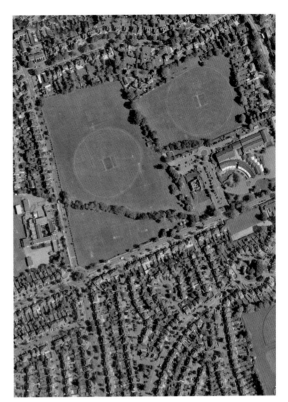

Laings £775 Detached House.

BACK RECEPTION ROOM WITH LARGE BAY WINDOW AND FRENCH DOOR LEADING TO GARDEN (NOT M.A. TYPE)

FR RECE RC IS SIMI WITH BAY W

Outstanding Features of LAING-BUILT HOUSES

ALL Houses are Detached or Semi-detached. The Detached houses at the reasonable prices quoted mark an epoch in building development.

Types T.A., M.A. and R.A. when Semi-detached have a joint car run, that is, an 8ft. space between each pair of houses for car access to the rear. In some cases it may be possible in these types to provide an independent car run or garage space of 8ft. at an extra charge. Types A.B.G. and E., etc., have their own independent car runs or garage space and same is included in the price of the house. This also applies to the R.A. Type when detached.

Detached Houses have 8ft. garage space one side and 4ft. passage space the other.

We make up all roads and footpaths free of charge to the purchaser and sell the houses definitely free from all costs in this respect.

Purchasers have a wide choice of decorations, including the paint work inside and outside, the wallpapers, the wood mantelpieces and the tile surrounds. Interior woodwork is painted or brush-grained to purchaser's choice.

Page Eight

Our Show-houses are exact specimens of the houses sold in construction, fittings and finish, and all houses are sold on the understanding that they conform in these points with the specimen houses seen.

House Types T.A., M.A. and R.A., with few exceptions conform to the same general specification given for the other types.

Laings pay all legal charges and stamp duties in connection with the conveyances and mortgages prepared by our solicitors. Also the Building Society survey fee.

NO.1 BEDROOM WITH BAY WINDOW. THERE IS A TILE COAL FIREPLACE AND A GAS POINT

NO.2 BEI SIMILA ALSO WI WIND (NOT M.A

Page Nine

STANMORE
— MIDDLESEX —

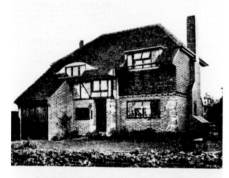

SPECIALISED HOUSES FOR SALE From £1,100

HENRY J. CLARE
OLD CHURCH LANE, STANMORE
PHONE · · · · · STANMORE 344

Also HOUSES FOR SALE
SEAWAY LANE, TORQUAY, DEVON
PHONE · · TORQUAY 3411

Clare's Advertising Brochure

In the 1930s John Laing was building houses to a design and quality and with gardens that people wanted and could afford. A long time before, in 1547, land had been assembled and kept in Crown ownership to benefit St Bartholomew's Hospital 'forever'. This restriction was waived in November 1926 and in June 1931 the site was sold. Farm land north of Wemborough Road became playing fields for Messrs Catesby (makers of cork lino) and Carreras, the tobacco firm. Wemborough was revived in the 1930s by Laing. 'Wyneberwe' had been a field name in about 1276 and 'Wimborough' the name of the Manor in 1713. Laing thought the area was well located and his prices ranged from £610 to £1,100. His road names were of Cumbrian origin, as was he himself. Clare's advertising brochure shows a typical house type of the time. His *Ideal Homes* for sale were from Barn Crescent to the Ridgeway and were £1,095 for a 3-bed semi-detached to £3,995 for a 6-bed house.

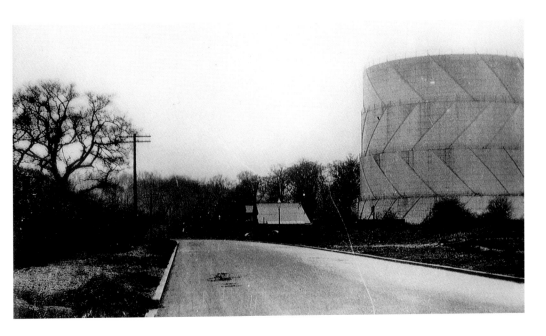

Gasworks

The gasworks in Marsh Lane have been a feature in the street scene since they were opened in March 1859 under the management of the Stanmore Gas Company. They were superseded by the Harrow & Stanmore Gas Company in 1894, the Brentford Gas Company in 1920 and the new funding for public utilities now in place enables customers to buy gas from Electricity companies and vice-versa. The picture here shows the newly made Honeypot Lane.

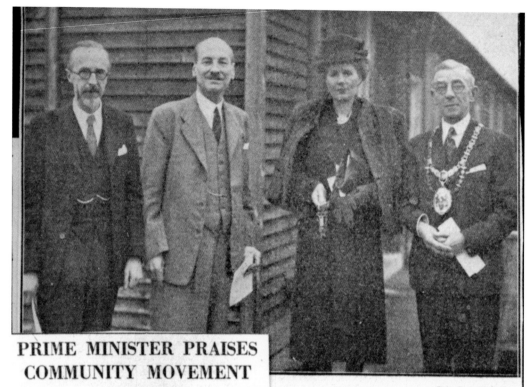

PRIME MINISTER PRAISES COMMUNITY MOVEMENT

Centre Opened by Mrs. Attlee

Mrs. Attlee, Mr. F. W. Skinnard, M.P. (left) and ...ons Park Community Centre, Stanmore, on Saturday.

CANONS PARK ASSOCIATION'S ENTERPRISE

Newspaper Report on Clement Attlee

The outbreak of war in 1939 interrupted building work, including the building of community centres, which Laing's considered should be provided on all their estates. The Council was also in favour of community centres including the vacant site Laing's had kept in Wemborough Road. Laing's retained this site and handed it to the Middlesex County Council who leased it to 'Lancanpar', the Laing's (Canons Park) Community Association. A separate group, the Canons Park Community Association, was initiated in 1943 and as a temporary measure two wooden huts were rented by them in Merrion Avenue. The front hut was used as a games room and the main hall in the second hut was capable of seating 250 people. The premises were officially opened by Mrs Attlee, the Prime Minister's wife, in November 1946, as the Attlees were Stanmore residents. Clement Attlee (*see page 91*), the then Prime Minister, said that 'Democracy means that people do things for themselves and do not wait for other people to do things for them... When I lived in Stanmore I was an inhabitant of a dormitory. I never saw Stanmore except at weekends. I have now ceased to be your neighbour, but I shall not cease to have my interests in Stanmore.' In due course, two groups shared the temporary use of Marsh Farm House pending progress on government funding the present premises. The official opening of the Canons Community Centre took place on 30 September 1972, forty years ago this year, at a cost of £32,000.

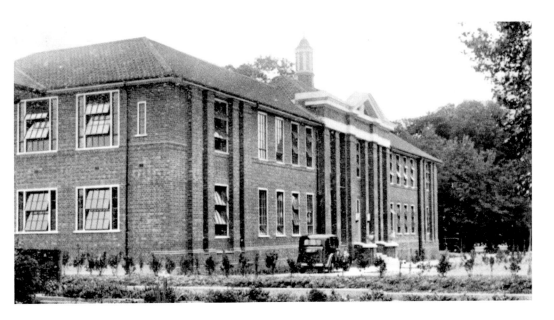

St Thomas' School

The Roman Catholic Church of St Michael in Du Cros Drive was created in 1938 and was based on St Thomas's High School for Senior Girls and the Dominican Convent next door. In wartime Polish airmen from RAF Bentley Priory attended mass here in the Convent Chapel. The parish was re-designated St William of York in 1958. The new church was designed by Hector O. Corfiato (1893–1963) and built in 1959–1961. It was listed in 2006 for its special architectural quality. The 1964 Christmas Fair was opened by the film star Roger Moore (*see page 90*). In 1978 St Thomas' school closed and the Convent was sold to build seventy-nine houses and flats. In 1974, Revd Pat Goodland and ten members of Stanmore Baptist Church visited a housing scheme for the elderly in Harrow, to consider one for Stanmore. A site was offered in Elizabeth Gardens by Mr & Mrs Mesger and Stanmore Christian Housing Association (SCHA) was established. Work began on thirty-nine single-person flats and eight two-person flats for the elderly and 'Paxfold' were opened in June 1979 by the Mayor of Harrow. In 2007 SCHA merged with Harrow Churches Housing Association.

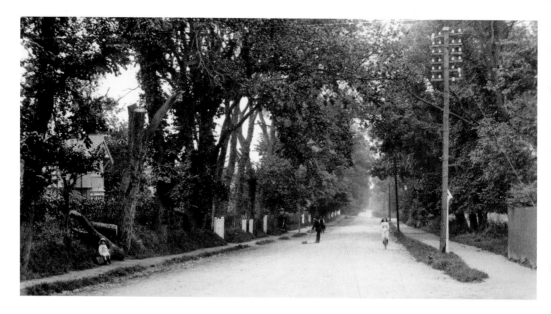

Marsh Lane & Nelson Road

The first wave of residential development, the ubiquitous and popular 'semi', came in the 1930s. Along the main roads like Marsh Lane, Honeypot Lane and Uxbridge Road, where existing housing densities were low, higher densities are regularly achieved on redevelopment where groups of houses have been bought up and replaced by flats. Since the year 2000 this approach has continued apace although it has merely continued the trend already set earlier as at Burnham Court, built in Marsh Lane in 1987. Farmland was lost to housing between 1928 and 1935 where the Council built terraced housing in Haig Road from 1928. Housing began even earlier in Elm Park, reflecting the slow growth of the centre. In the side roads there was a mix of builders from Mr Spurgeon, who built a pair of houses in Silverstone Way in 1947, to larger scale operators. Burnham Court is seen below.

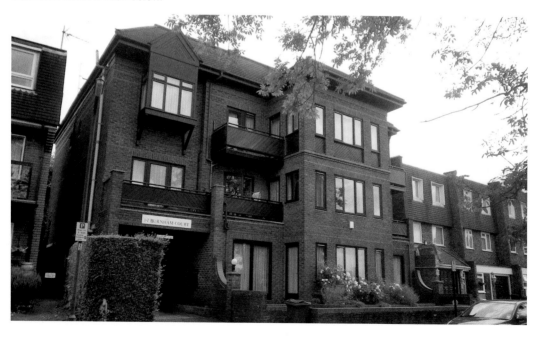

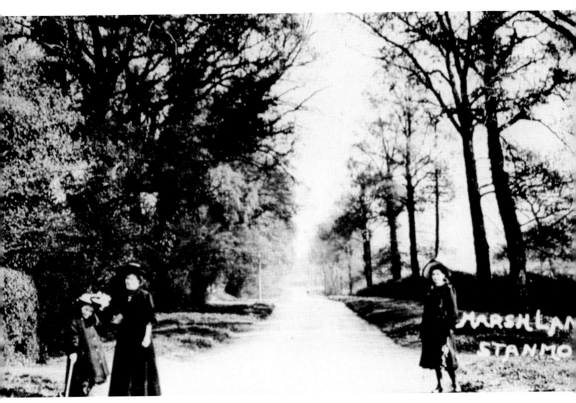

MARSH LANE
STANMORE

The Chapel

Worship at Stanmore Chapel began as early as June 1932 with the Revd Reed (pastor 1932–1969) administering to six adults and two children in an old barn on Old Church Lane. With the barn too small for worship, larger premises were sought and found (at 1 Abercorn Road), but the builder, Henry Clare, had expected the building to be financed by the Baptist Union. The majority of members were not prepared to do this and received a notice to quit in August 1935. The present site was bought for £300 in 1936, a manse followed in 1957 and a new hall after 1945. Stanmore Chapel has remained independent ever since, funding and opening its own premises on 23 October 1937. The change of name to Baptist Chapel was meant to avoid confusion with the Baptist Church nearby.

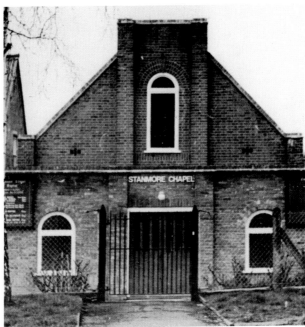

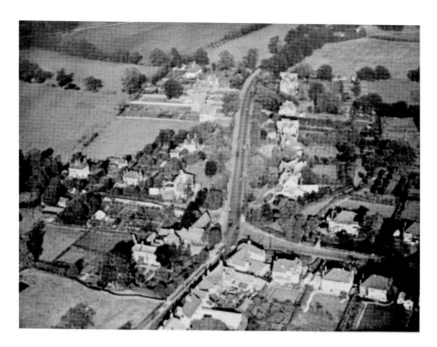

Dennis Lane

Marsh Lane is crossed by the road from the commercial centre to the Underground station and proceeds uphill to the Stanmore ponds by way of Dennis Lane. This is an old road, which was well established by 1754 and indeed is referred to as Dennis Lane in 1578. It is said to be named after Dionesia Bucaute, a land owner of the thirteenth century. It could well be seen as part of a pre-Roman trackway, which linked the crossing of the River Brent at Neasden to Marsh Lane by way of Honeypot Lane – in which case the route could be not only parallel to, but also older than Watling Street. (© *English Heritage. NMR Aerofilms collection*).

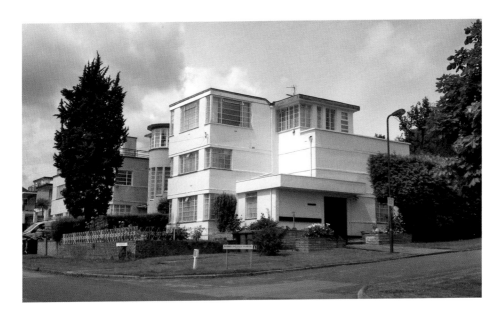

Kerry Avenue

The new stations on the Metropolitan line and its extension to Stanmore created commercial centres, as well as residential estates, which collectively have been called 'Metroland'. Unlike other stations, retail parades did not appear at Stanmore station. Instead, within four years of the station opening (1933–1937) modern housing at Kerry Avenue for the twentieth-century commuter was built to a challengingly modern design, receiving Conservation status, by Gerald Lacoste (1909–1983), Douglas T. Wood and Reginald H. Uren (1906–1988). Formerly part of the Warren Estate, building permits were received in 1931 by Sir John Fitzgerald, Irish Baronet and Knight of Kerry, who inherited the land in 1922. The steel framed Crittall windows are typical of this international style.

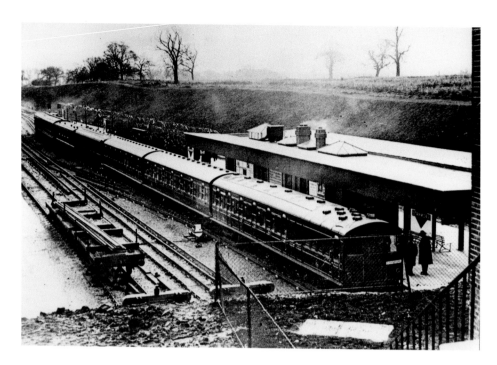

Stanmore Station

The Metropolitan Railway opened its own Stanmore station about east of Stanmore on 10 December 1932. The line later became the Bakerloo line in 1939 and from 1979 the Jubilee line, giving a direct service to the West End. It was designed and built in 1930–1932 by C. W. Clark in his traditional suburban style. Unlike other stations on the Stanmore branch line, the creation of a new station here in the 1930s did not bring about a new centre. In the event, the station was and remains relatively distant from the shops although bus services link the two. (©*TfL from the London Transport Museum collection*)

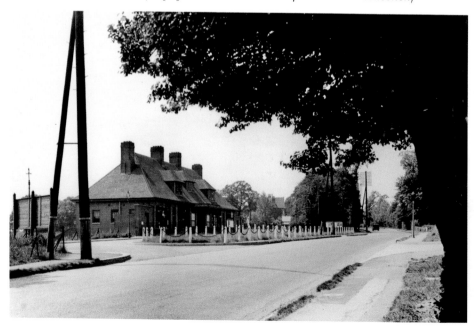

Central Stanmore

From Stanmore Hill to The Broadway and out to the Churches

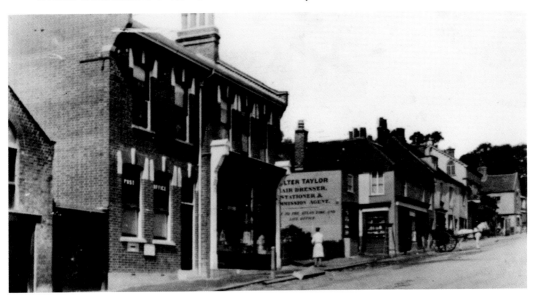

Stanmore Hill

The 1920 edition of the Ordnance Survey map indicates how and where the town was growing. It had in fact spread to form two distinct clusters, one at the top of Stanmore Hill, centred on the junction of Green Lane and Stanmore Hill; and the other grouping to the south at the road junction of Church Road and Stanmore Hill that spread to infill the southern frontage of the Broadway from the Memorial Institute to the farm at the corner, with Marsh Lane and both sides of Church Road. These two clusters were to merge to form the recognisable centre of Stanmore we know today. The commentaries given by Mr Leversuch (1970), Alf Porter (1980) and Barbara Robbens (2012) have helped us understand the basics of how the village prospered and grew. Below is the Queen's Head, situated at the bottom of Stanmore Hill.

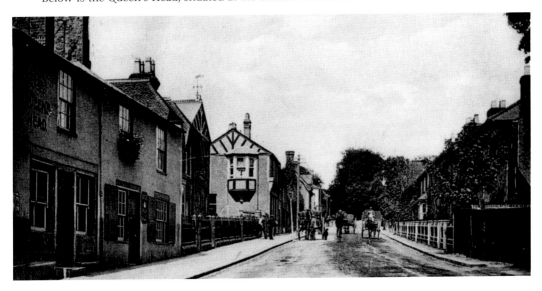

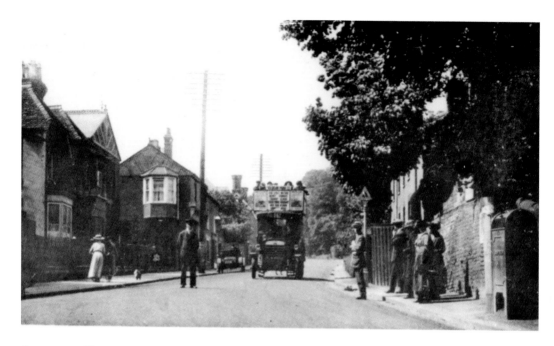

Stanmore Hill

The hill has a significant collection of eighteenth- to nineteenth-century buildings, which reflect its historic growth. It is possible to single out some of the more arresting sights on the way up before the former brewery buildings are reached. Nunlands (No. 23) is an attractive Georgian house, with square labels around the windows, but with textured paint. The old bank at No. 19 is an attractive Victorian piece with bracketed eaves and red-brick diaper work. Stanmore Hill was known as Loscombe Lodge in 1899 after its owner C. W. Loscombe, and was called Robin Hill in the 1930s. It was formerly the home of Edward Wilson (1872–1912) the explorer and naturalist who died with Scott on the South Pole exhibition in 1912. Its Georgian features include sash windows, a broken pediment, key stone and a panelled door.

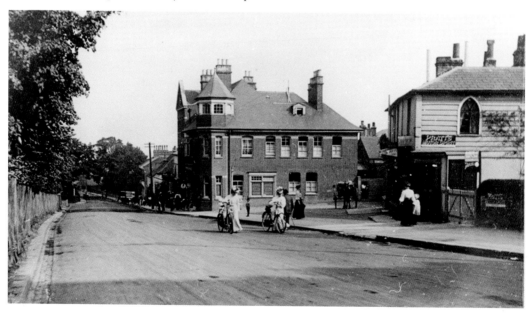

The Larger Houses

Clutterbuck's Brewery dated from the eighteenth century and took its water supply from the artificial pond opposite, now known as the Brewer's pond. The Rookery is a late seventeenth-/early eighteenth-century red-brick house with a clock tower and cupola dating from 1745, which had stables for the brewery. Hill House, now 173 Stanmore Hill, was where Dr Samuel Parr set up a school in 1771 in opposition to Harrow employing somewhat unorthodox methods. He was forced to close in 1776. From 1852 the property was the home of Charles Fortnum (1820–1899) of Fortnum & Mason, collector of antiques and statuary and a trustee of the British Museum. Woodlands was the home of Lord Halsbury, the Lord Chancellor, who lived here from 1885 until his death in 1921. Halsbury Close now occupies the site.

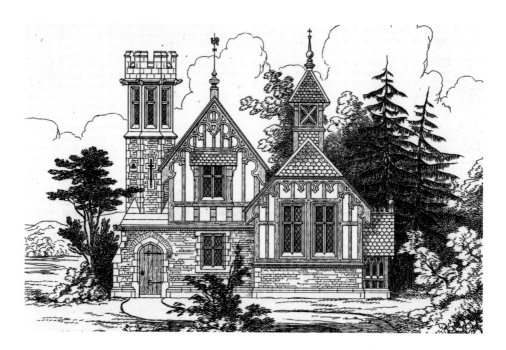

National School

A National School was established in Stanmore in 1826. Land was given for a replacement infant school in 1845, which enabled the National School to move to a new site in 1861, accommodating 600 pupils with an average attendance of 260. It flourished here until comparatively recent times; then shuffling accommodation began to improve the facilities. The juniors moved into St John's School in Green Lane in 1960 from the National School. The infants then moved out of their old school into the former National School and then joined the juniors four years later. This enabled the former infant school to be demolished in 1963 and the National School in 1970. The Cot at No. 80 is a detached two-storey, half-timbered building dated 1839. Between it and the workhouse, was the Abercorn Arms.

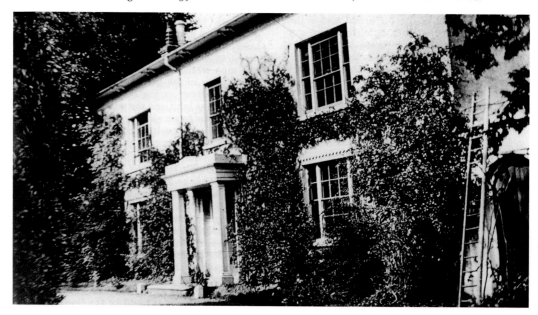

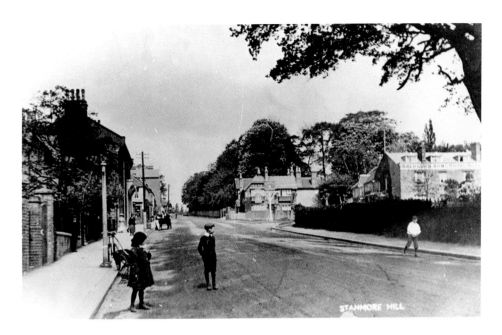

Abercorn Arms

The Abercorn Arms has an imposing three-storey frontage with pediment built *c.* 1800. It was here that the Prince Regent, and King Louis Xviii (1755–1824; *see page 90*) met on 20 April 1814 to commence the King's return to France. He had been in exile in Buckinghamshire until 1814, awaiting the defeat of Napoleon. The King's return to London in 1814 started with him leaving Hartwell House on 20 April 1814 to arrive at the Abercorn Arms in Stanmore at 14.00 hours. They then left for London at 15.00 hours, while dignitaries had left Carlton House at 12.30 to head out to Stanmore to ensure that Crowds would line the route. 'The town of Stanmore exhibited the most novel sight possible to be conceived; there was not a house, but exhibited tokens of respect by the emblems of white – some, to shew their zeal to a great extent, actually displayed sheets and pillow cases.'

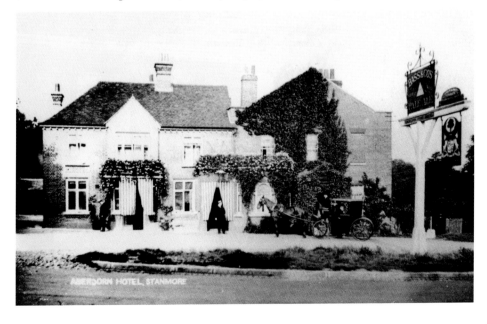

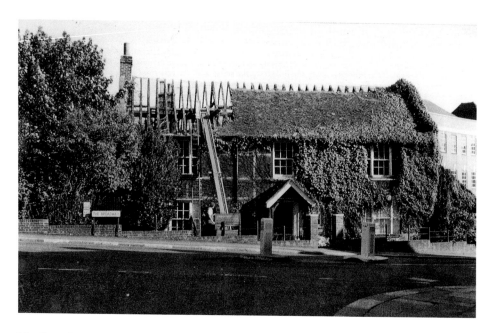

The Broadway

The Great Stanmore Parish Council agreed to acquire the 5.5 acres of this Recreation Ground in December 1928 and it was in use as Stanmore Recreation Ground by 1932. Of the more unusual events in the park it hosted the Stanmore Carnival in 1996–1999. At the junction of Stanmore Hill and Church Road there stood Buckingham Cottage, which today would be opposite Barclay's Bank. The site appears to have been previously known as 'Mackrells'. The demolition of Buckingham Cottage seen here in 1961 made way for the redevelopment of this site, which now comprises shops and offices known Buckingham Parade, ending with Wetherspoon's. Stanmore Library, which lies at the other end of the parade, was opened to customers about 1986. The parade of shops at 14–30 The Broadway appears part of this development. The photograph from 1913 shows a bus on route 106 about to enter The Broadway. (©*TFL from the London Transport Museum collection*).

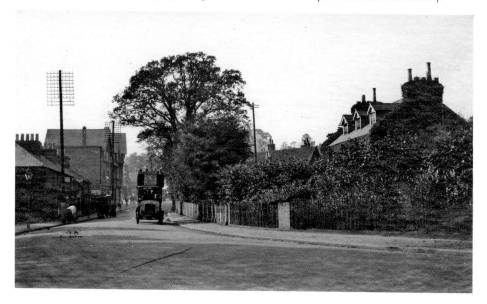

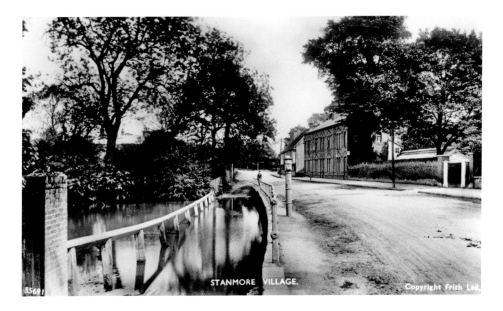

Stanmore Village

A picture of the village pond, which lays near Nationwide Building Society looking towards Dennis Lane, and the same view in 2012. The pond was filled in about 1914/15. On the north side of The Broadway today are the main shopping parades of the 1920s/30s. Before they were built, they were formerly the site of the village pond, which featured on postcards of the time as it added to the charm and character of the village. Cottrell's is a two-storey, timber-framed, jettied building, possibly once alms houses, which dates from late sixteenth/early seventeenth century, in some accounts specifically to 1565. Its length of 98 feet makes it one of the longest continual jetties in the country. Originally it was 110 feet long, but one bay was removed in 1865. Named Pathgate in the sixteenth century it is now named after the man who restored the building in 1968.

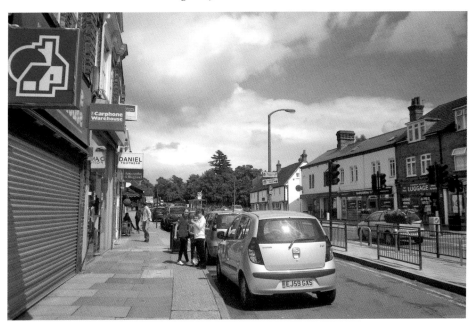

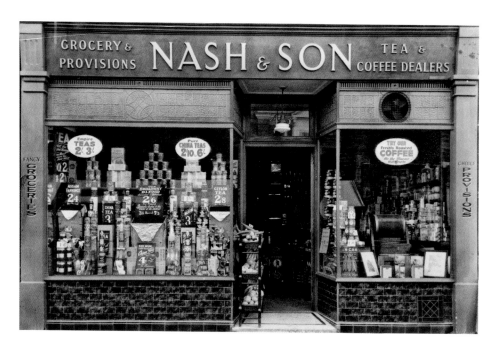

Bernays Institute

Today, as Caffè Nero, the use may not have changed, but the shop dressing has done. Although part of this Victorian/Edwardian parade was occupied as an AA building – Fanum house – now Carpetright; the most striking building is probably the Institute. The Bernays Institute was built as a parish hall and stands at the centre of Stanmore Broadway. In 1924 Revd Stewart Bernays (Rector 1898–1924) wrote of the opening of the hall at a cost of £1,470 in 1872. It was this Rector who in describing Stanmore coined the phrase 'A little place but our own'. The Ernest Bernays Memorial Institute is of Victorian Gothic design and bears the date 31 August 1870. It commemorates the accidental death by drowning of the son of Revd L. J. Bernays, who was the Rector of St John's between 1860 and 1883. It was used for bible classes on Sunday afternoons, for the Band of Hope and for the Temperance Society. Social activities of the church are held in Old Church Lane.

Next to Sainsbury's and the Crown; Westwards to St Johns

To the west, on the south side stands Sainsbury,s with its modern frontage design and 'community space' while above to the west a modern tall building is a little out of village character if not in colour or design then at least in scale, established by the parades of the 1920s/30s. The upper floors are set back, however, which reduces the intrusiveness of the building's bulk upon the street below. Barclays and the adjoining bank buildings give a more appropriate backdrop when viewed descending Stanmore Hill. Leversuch recalled the street scene as an entrance to two stables, then the 'Fountain Inn' and a range of small businesses before reaching Elms Park.

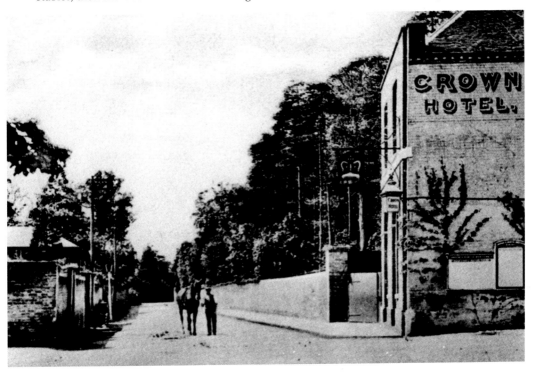

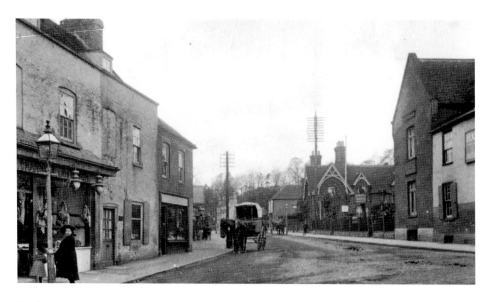

Bank Sites

The heart of Stanmore has lost something of the charm and scale it once had; modern building materials and storey heights often being out of character. At least it has contained, or so far resisted, the worst of development pressures. An alehouse called the Queen's Head stood on the south side of Church Road and was there by 1714, but was cleared in due course for banks like the London & South Western Bank prior to the amalgamation with Barclay's in 1918. Some customer accounts still go back to the 1890s, but the earliest bank building appears to have begun business in Stanmore Hill. The Queen's Head then moved across the road leaving three pubs from the bottom of the hill to the Vine at the top, not including the Abercorn Arms, which was licensed in 1803. Next to the new Queen's Head on the north side of Church Road, was a building with imposing barge boards, which had an integral telephone exchange. Later, the Exchange moved to its current site in Elm Park. Bedford's Stores came next, followed by Regent House and cottages and the high front wall to the 'Elms'.

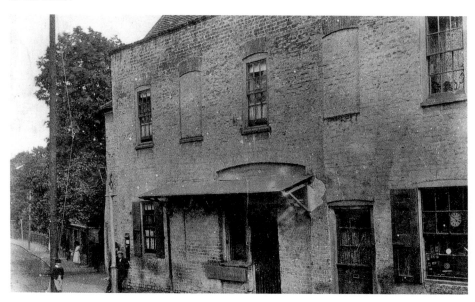

Apollonia Restaurant Site

The older properties that stood on the Apollonia Restaurant site have now all been demolished with one exception and that is Regent House. At various times in the recent past the property has been used as a milliner's and surgery. The property seems to be a medieval hall house in a good state of preservation. The accommodation under the crown roof appears as early as 1470, to which was added in the late eighteenth century a then fashionable brick front and parapet, creating an attractive two-storey house. English Heritage is of the opinion that it is the only example of medieval architecture to survive in the parish and is even older than the seventeenth-century church ruin.

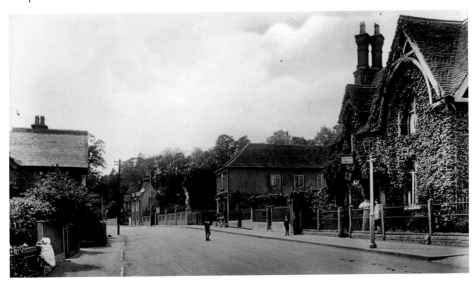

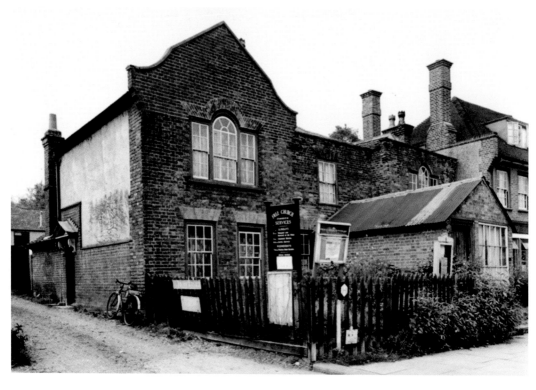

Church Road
A Georgian house in Church Road, with a Venetian window, *c.* 1914. It stood next to Bedford's store and the telephone exchange (with the striking roof gables) and opposite the Fountain pub.

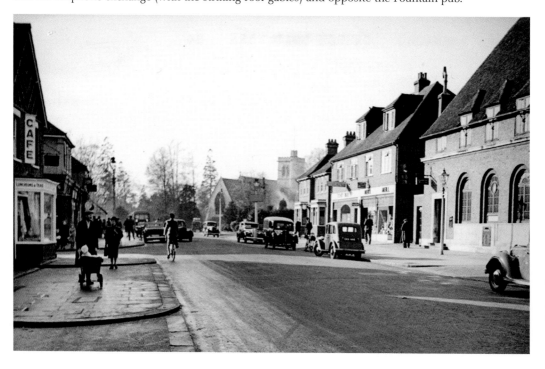

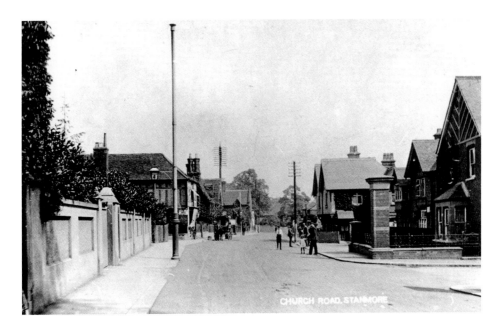

Then & Now

Approaching the churches, and next along Church Road, local historians, Mr Leversuch and Alf Porter, recalled the walled garden fronting the 'Elms', behind which the property was hidden. The house was demolished about 1920. Further still was the Crown Hotel. It was replaced in the 1930s and remains a pub though renamed the Crazy Horse. The landmark tree of fond memory alas has gone.

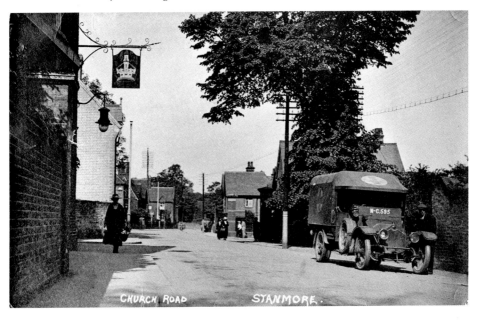

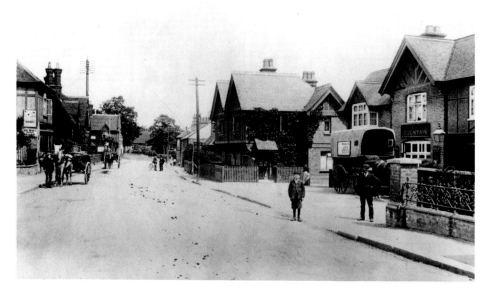

Fountain Inn

At this point, on the south side of Church Road, was a row of small cottages, mostly converted into shops. Two of the cottages, one of which was a petrol filling station, were demolished with the adjoining 'Fountain' public house in *c.* 1969/70. The Fountain had been rebuilt in *c.* 1900 and early postcards show it with the parish well in front. Beyond this was Elm Park, which was opposite the Crown.

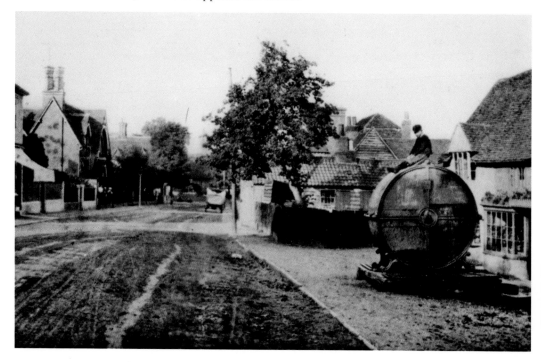

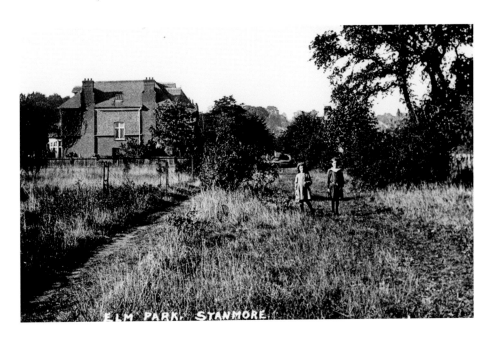

Elm Park

Elm Park was a footpath across the fields to Old Church Lane and the site of the old church. It then came to serve a different purpose in opening up access to allow for possible houses to be built behind. More recently, as a road used by shoppers to access a shoppers' car park, it has been closed by a barrier to stop the rat-running of traffic through the residential streets.

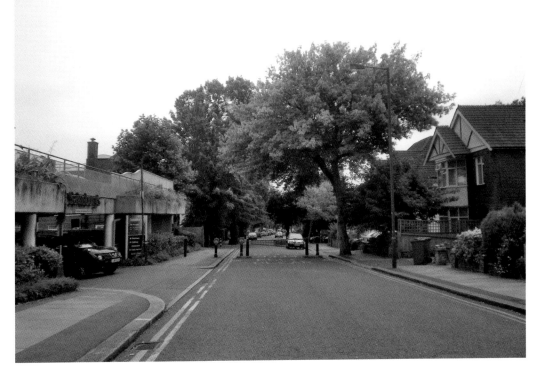

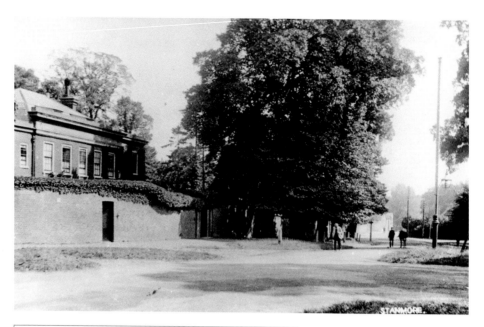

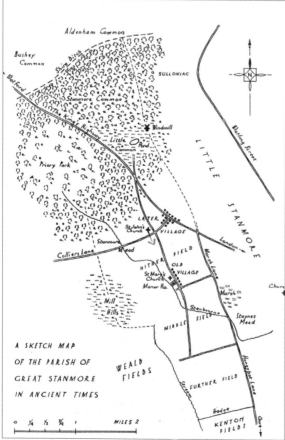

A SKETCH MAP
OF THE PARISH OF
GREAT STANMORE
IN ANCIENT TIMES

Buildings in Ruin

Pynnacles stood in Green Lane. In 1849 its occupant, Lt-Col. Tovey Tennent, gave the land required for the new church. In 1891, the Wickens sisters, who ran the cottage hospital, lived here, as did Mrs Arthur who established the herd of deer at Heriots. In 1930 the premises, then a school, were destroyed by fire and demolished in 1932 to make way for road widening. Pinnacles Close now occupies the site. Stanmore's first church was probably built in the fourteenth century near the junction of Wolverton Road with Old Church Lane. Maps from 1754 and the Stanmore Tithe Award of 1838 indicate the 'Old Church' site. The Church was dedicated to St Mary and the tomb of the Revd Willoughby (rector here in 1563–1610) lies in the garden of a house in Old Church Lane. It was replaced by the now-ruined brick church in 1632, reflecting the shift in the village.

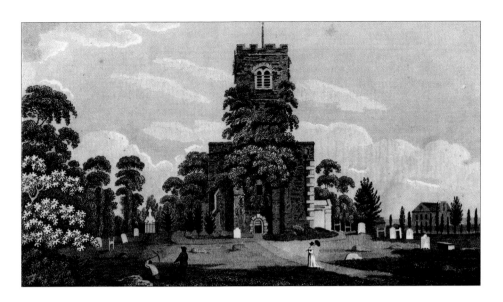

The Second Church

This replaced St Mary's in 1632, but is now an attractive brick ruin. Its location away from the earlier medieval site reflected the shift of the village centre to the north. It was here, from the 1500s, that the Manor House stood at the top of Old Church Lane until it was demolished in 1930 by Samuel Wallrock in his creation of an estate in imitation Tudor. This brick church was built by Sir John Wolstenholme (1562–1639), a wealthy and influential merchant adventurer who helped finance the exploration of northern Canada. It was consecrated by the Bishop of London, William Laud, on 17 July 1632, who, in the following year, was made Archbishop of Canterbury. He was beheaded on 10 January 1645, four years before King Charles I, to whom he had become a senior advisor. An accusation against him was that he had consecrated a private chapel, which was considered a papist practice. Pictured is the brick church in 1807.

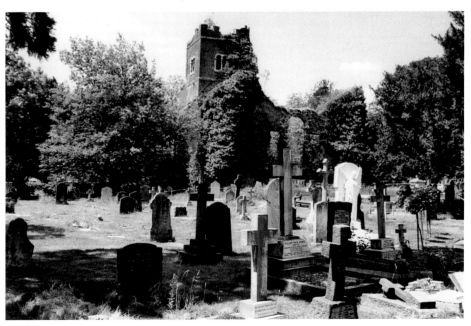

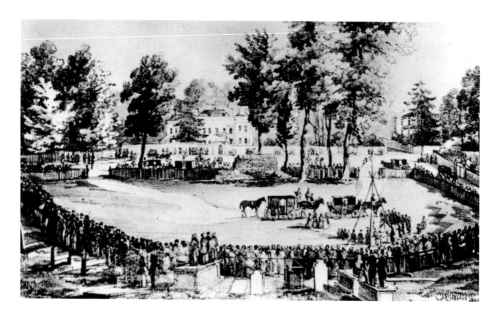

St John's Present Church

The new church of St John was designed by Henry Clutton of Surrey and the stone-laying ceremony took place on 14 March 1849 in the presence of Queen Adelaide, then living at Bentley Priory, who was the widow of King William IV. This was to be her last public engagement prior to her death on 2 December 1849. The site was given by Colonel Hamilton Tovey Tennent of Pynnacles. The opening ceremony was performed by George Gordon, the 4th Earl of Aberdeen (1784–1860). He had not only been Colonial Secretary, Prime Minister and had given £2,000 to the building fund, but had also married Catherine, the second daughter of the Marquess of Abercorn. Pictured is the church in 1905.

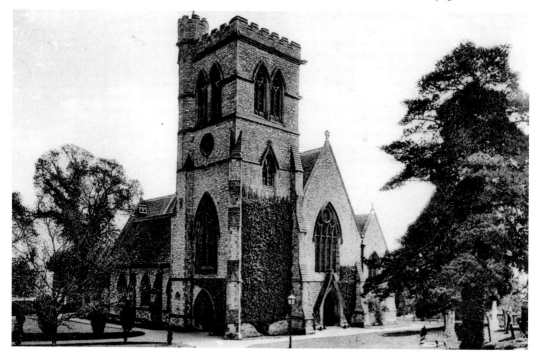

St John's Present Church

The church cost £8,000 to build and was officially opened on 16 July 1850. It replaced the old brick church, which was too small for the growing parish and was showing signs of structural instability. Although the Earl was buried in the ruined brick church in 1860, the location of his burial remained lost for many years until his coffin was rediscovered by the Old Church Working Group, headed by Dr Freddie Hicks in the course of works in December 1991. For works to consolidate the ruin the Group appointed Caroe and Partners. The works were completed in less than two years (1991–1993) at a cost well within the quote of £250,000. Pictured below, is his tomb.

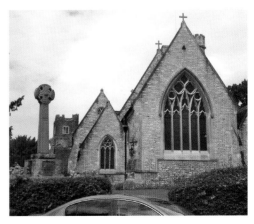

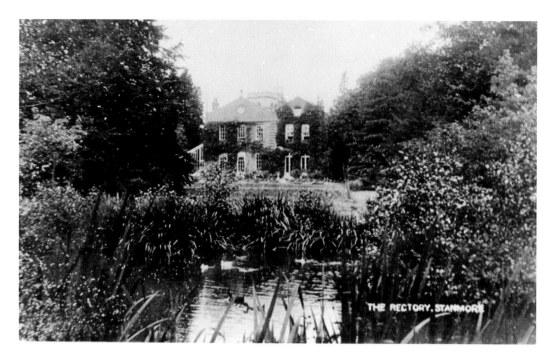

Rectory

The existing Rectory was built in 1960 behind earlier accommodation which the Revd George Hudson had built in 1721. The earlier red-brick three-storey house had proved expensive to maintain and was divided into two houses in 1949. The present Rectory Lane was at one time the main road out of the village, but was re-routed by the Drummonds to the present alignment of Uxbridge Road to achieve the enlargement of Stanmore Park and improve privacy within it. The house built as Wolstenholme in 1900 is now a retirement home. A school room once adjoined the churchyard but was replaced by St John's Church of England School at the top of Green Lane in 1960/64.

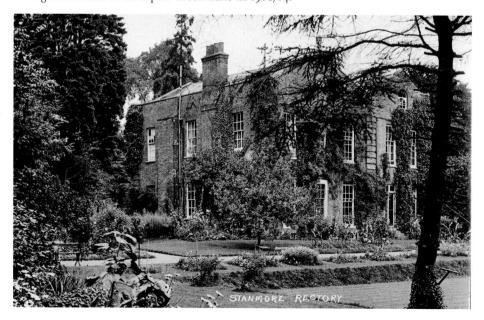

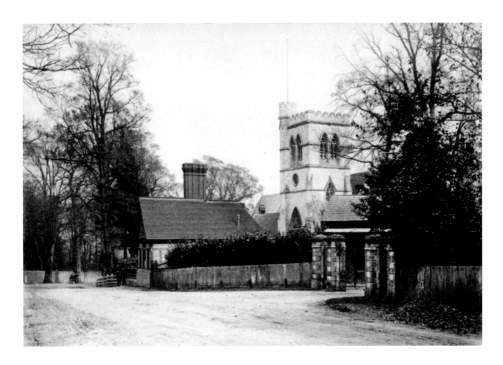

Church Lodge

Church Lodge, which adjoins St John's Church, was erected in 1881 in memory of Robert Hollond of Stanmore Hall (1808–1877). It was designed in an unusual 'gingerbread' style by Brightwell Binyon. Hollond married Ellen Julia Teed of Stanmore Hall in 1840. He was a lawyer and MP for Hastings. He was one of three who, on 7 and 8 November, 1836, travelled by balloon from the Vauxhall Gardens to Weilburgh, in the province of Nassau in Germany. With him were the balloonist Charles Green, and writer and musician Monck Mason. They flew 500 miles in 18 hours, thereby setting a record not beaten until 1907. Further flights took place in the 1830s before the flight of the great Nassau balloon of 1840. Station Road became the new name for what had been Old Church Lane as it led the way to the new station. (*See page 29*).

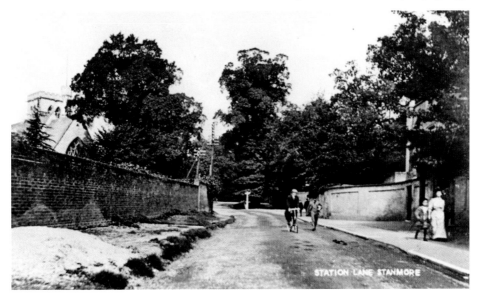

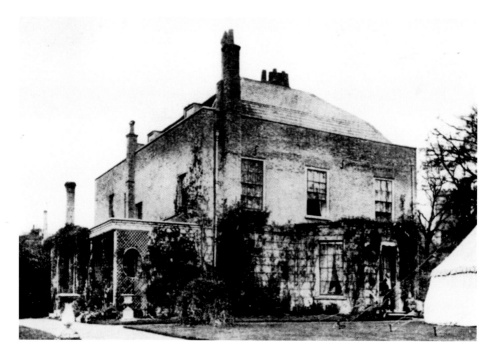

Manor House

Church House Cottage and Cowman's Cottage lie on the east side of Old Church Lane. The west wall can be dated to the sixteenth and seventeenth centuries and is original, but the cottages and outbuildings were largely reconstructed as a banqueting hall in 1930/35. A new Manor House called the 'Croft' was built in 1901 to replace the old one. The Manor House in Old Church Lane was pulled down in 1910 with this in mind and the Croft became the new Manor House. This was bought by Wallrock, a property developer, in 1923 and demolished in 1930. Wallrock remodelled it on Tudor lines from 1930 and its old brick boundary walls remain. This group of mock Tudor buildings was his creation. In addition, Wallrock (1891–1954) carried out an immaculate piece of Tudor construction. No expense was spared and at one time 120 workmen were engaged in the gardening but the extent of this took its toll and had bankrupted him by 1933. The gatehouse bears the inscription 'Welcome Ever Smiles and Farewell Goes Out Sighing.'

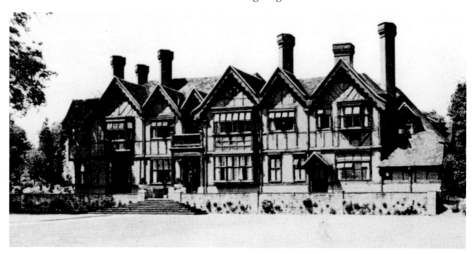

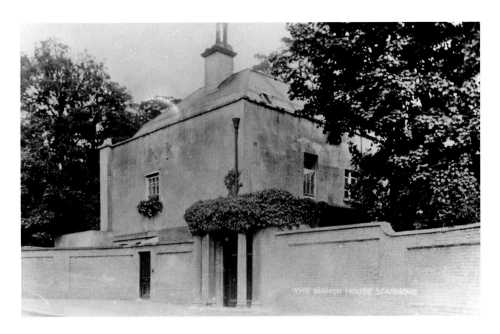

Old Church Lane

In his imitation Tudor design for Old Church Lane Samuel Wallrock spent £100,000 on securing genuine 450-year-old glass, oak panelling, a minstrel's gallery and an oak staircase. It remains a reconstruction of some magnificence. Notwithstanding the vision, Wallrock was forced to leave in 1933 because of financial difficulties. The Manor House and gardens remained empty until September 1939 when it was acquired by the Air Ministry as the Headquarters of Balloon Command. An earlier moated Manor House, built in 1235 near the junction of Belmont Lane and Abercorn Road, has not survived.

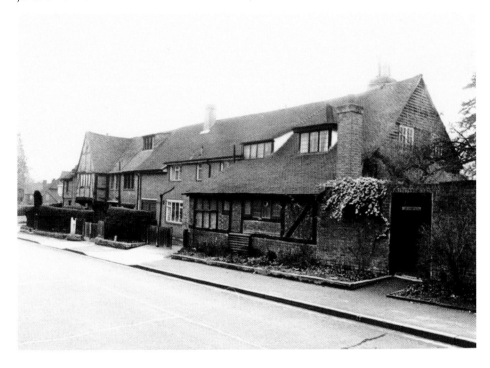

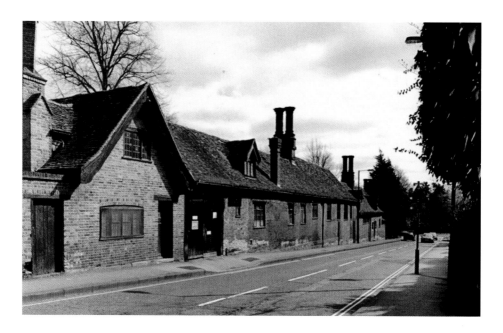

Mock Tudor or The Real Thing

St John's Church acquired the Church House opposite in Old Church Lane for its social gatherings in 1947. Its 1930s construction is convincingly disguised behind a mock Tudor design, which the owner, Samuel Wallrock, adopted for both the banqueting hall and Manor house. In the recent development by Laing further south at Cherry Tree Way, a more restrained 'Tudoresque' design is promoted with an appropriately darker toned colour of brick. The head gardener's cottage on the Wallrock's estate was demolished after 1963 and replaced by the town houses opposite in Tudor Well Close built in 1970. The Tudor well at the road junction is likely to have been an 'import' by Wallrock to add finishing touches to the Tudor character. The Lych Gate on the west side of the road was built of old timber in 1930.

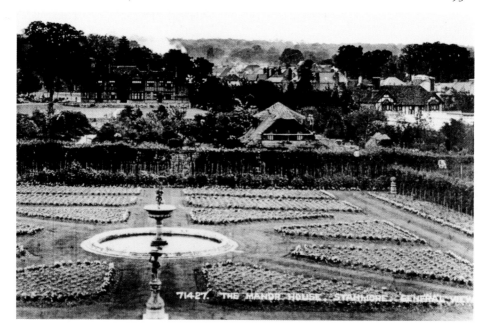

The Northern Limits

From Stanmore Hill to Brockley Hill

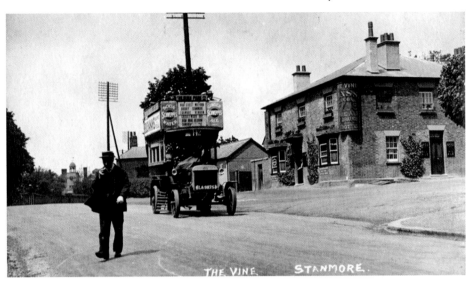

The Vine

At the top of Stanmore Hill stands the Vine public house; the present structure was built in stock brick about 1840. Thomas Clutterbuck had acquired an earlier building in 1762 and from here London could be seen, and still can be. Coaches ran between Stanmore and Holborn in 1803 and twice daily from the Abercorn Arms for Oxford Street in 1826. By 1845 the Vine was a stopping place on the London bound coach service from Bushey. The improved services of the London General Omnibus Company in 1912 made Stanmore more accessible still. Indeed the history of London's expansion has been one of continuing improving accessibility as with the introduction of route 324 operating between stations through Stanmore in 2011.

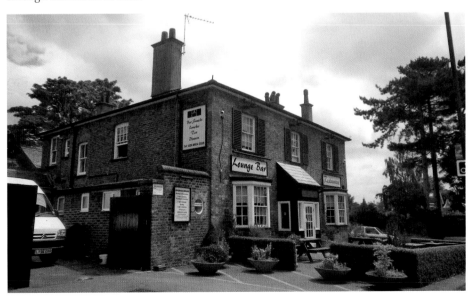

Little Common, Ponds & Bowling Green

Little Common, the village on the hill, is a collection of pretty cottages that date from the eighteenth and nineteenth centuries. Those which overlook Spring Pond are later, built in the Victorian Gothic style of the 1860s/70s. The legend that Caesar's ponds were dug here to serve the Roman legions is unlikely to be true. The two-storey Parson's Cottage dates from the mid-1700s when it was built as a house and bakery, and a Mr Parsons was the baker. A terrace of cottages faces the common while the two- and three-storey Faircot faces out of the area towards Stanmore Hall. By the roadside, a disused nineteenth-century water pump indicates its original use. One of the ponds with hill top gravel may have been the original stony mere of Stanmore. The bowling green was important enough to be mentioned on John Rocque's map of 1757. It was owned and rebuilt by the first Duke of Chandos, let out for entertainments in the 1700s and demolished by Thomas Clutterbuck a century later.

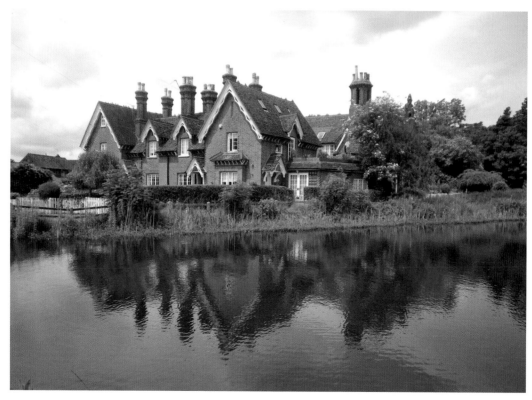

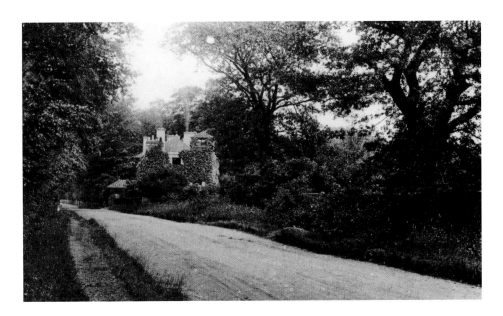

Stanmore Hall

Wood Lane connects Stanmore Hill to Brockley Hill, a road which runs along the northern ridge, and from it access is provided to Dennis Lane and to a number of substantial properties. Dennis Lane falls steadily from Spring Pond and Stanmore Hall to reach the town centre. Viewed on the hillside, however, from across the London basin Stanmore Hall appears as an impressive stone mansion with a Gothic lodge. It was built in the mid-1840s for John Rhodes by the Irish Architect John Macduff Derick (1805/06–1859) and was the home of Robert Hollond, MP (1808–1877; *see page 90*) who, in 1836, flew to Germany in what would be regarded as the early days of flight. Ellen Hollond who outlived her husband and died at Stanmore Hall in November 1884, was a writer and founder in 1854 of London's first crèche.

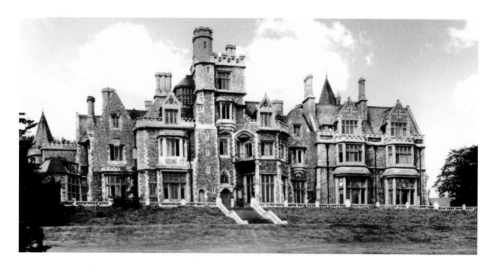

Stanmore Hall

Stanmore Hall was considerably enlarged in 1885 for William Knox D'Arcy (*see page 92*) who added the east wing and tower (designed by Brightwen Binyon) with fine William Morris interiors. D'Arcy made a fortune in establishing a gold mining company in Australia, which he spent prospecting in Persia. There he discovered oil in May 1908 restoring his fortune and founding the Anglo–Persian Oil Company, now British Petroleum. When he died in 1917 he left in his will £12 short of £1 million. The house was used as assize courts by United States troops in the Second World War and as a nurse's home. By 1971 it was standing empty and facing an uncertain future. Damaged by fire in 1979 it has since been restored. This is a prestigious development, with a two bed flat priced at £650,000. (*By courtesy and permission of Anthony Breslauer*).

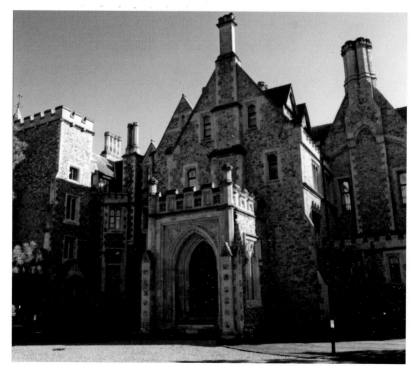

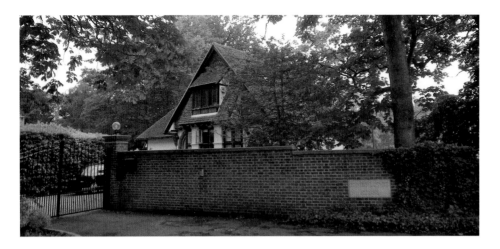

The Limes Lodge House

The striking Lodge House has more of an impact on the street scene than the house itself. Nevertheless, Limes House in Warren Lane was the home of the aircraft pioneer, Sir Frederick Handley Page (1885–1962; *see page 95*), from 1922 until his death. By 1917 Handley Page needed larger premises and so a site was compulsorily purchased and a new factory and aerodrome were laid out alongside Claremont Road in Cricklewood. Handley Page closed its Cricklewood Aerodrome in November 1929 and received a royal opening of its new airfield at Radlett in July 1930. The mound in the grounds was excavated in 1954 and found to be of post medieval date. About 1800 the Grove passed from the Capadose family to a Mr Fierville, who not only made a lake between his house and the Common but built a fashionable grotto with the discarded soil. This he lined with shells. A third mound on the estate was an ice house. These features still survive. Between 1872 and 1906 the house was the home of Eliza Brightwen. She was a writer of girls' periodicals and, between 1891 and 1909, of richly illustrated books about local natural history. Widowed in 1883 she died in 1906. It was bought by Sir Edward Cassel for his daughter but the General Electric Company took over the building.

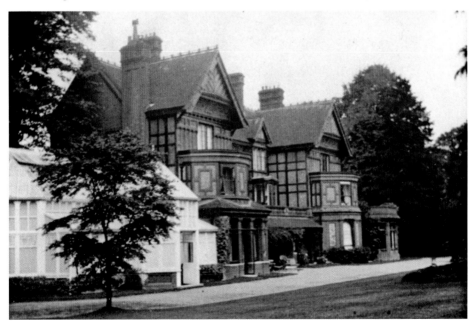

Marconi and Housing Site

After Grove Estate had been acquired by the GEC in 1949 a number of buildings for research and development were constructed on the site for the Ministry of Supply. By 1971, they were being used by Marconi Space and Defence Systems as part of GEC who demolished it in 1979. Their employees numbered over one thousand, making them the largest employers in the area. As contractors for government projects, the company was divided into four divisions – underwater weapons, space systems, guided weapons (which was transferred to MBDA at Stevenage), and electronic warfare (a division of Selex, now Selex Galileo), the products being designed here and tested elsewhere. Major cuts in Defence jobs in and after 1995 culminated in part of the company being acquired by British Aerospace. The bulk of the site was then sold for housing about 2005. The site, since called Bentley Grove, was developed for housing by Crest Nicholson in 2007–2008.

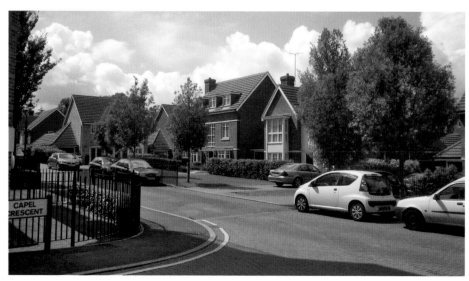

Cricket, Football, and Horse Riding

Stanmore Cricket Club was founded in 1853 on a pitch close to where James Brydges, the 1st Duke of Chandos, maintained a bowling green and a house of entertainment in the early 1700s. The club has nurtured test players such as Mark Ramprakash and was also crowned Middlesex Indoor Champions in December 2011. Umesh Valjee was awarded the MBE in the New Year's Honours in January 2012 for services to deaf cricket. Grove Farm currently incorporates pasture land located between the A41 highway and a new housing estate. Forty years ago it was a dairy farm; now with the passing of time it contains stables for a horse riding school. Harrow Rugby FC was founded in 1891 and beat Hampstead in its first match on 28 November 1891. The club moved from Spur Road to its present site at Grove Field in Wood Lane in 1953. The club built a new clubhouse in 1968 for the 1969–1970 season and keeps close links with the Saracens Club, with whom players enjoy close contact. There are sixteen teams competing at all ages.

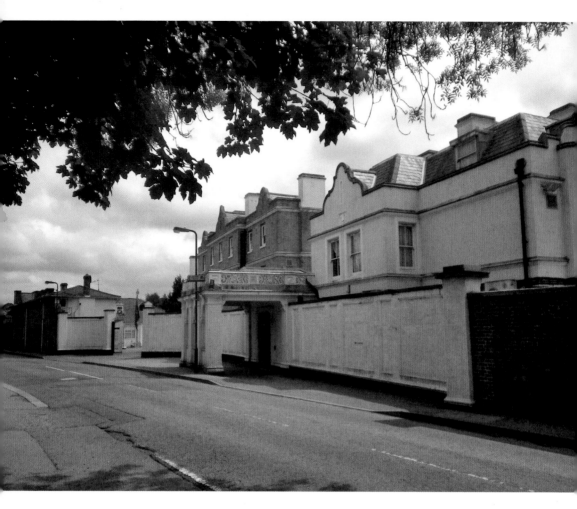

Husaini Shia Islamic Centre

The Husaini Shia Islamic Centre in Wood Lane was first known as Warren House and was bought by James Forbes (1749–1819) of the East India Company in 1780. The property has three storeys with a dominant entrance canopy on the frontage. The name relates to the wildlife on the common: the Coney (rabbit) warren covered 44 acres of Stanmore Common in 1714. After Forbes' death, Sir Robert Smirke, leased it to the Keyser family in 1851 and they remained there until 1890. Charles Edward Keyser (*see page 90*) was instrumental in purifying drinking water and thereby eradicating typhoid, epidemics of which swept London in the 1860s. In its earliest form, Warren House was old enough to predate Stanmore's brick church. A new wealthy clientele was prepared to give it an architectural make-over in a fashionable Georgian style and in this Sir Robert Smirke was employed in 1810–18. Smirke was later the architect of the British Museum. In 1951, it was bought to provide elderly persons accommodation and named Springbok House. It was run as a subunit of Edgware Hospital before it closed in 1978.

Eventually the Khoja Shia Ithna-Asken Community acquired it and converted it into an Islamic Training Centre which opened in 1987.

The Swaminarayan Temple, Stanmore

The Warren House estate included land along the ridge, from which views across London could be gained. The site comprised outbuildings to Warren House and more recently the remains of the previous keep fit centre, from which they became separated. The separate land holding was maintained when the Shree Swaminarayan Temple moved here from its premises in Edgware in May 2006, when the official opening of the Temple took place. There were also other events, as shown here, where boys and men are being led by a priest in hymn and song singing as part of the wider celebrations. The premises, set out on a 17-acre site, provide religious, social and education facilities for young and old alike. At the end of 2011 the Hindu temple celebrated its fifteenth anniversary.

Aspire

Aspire was founded in 1982 at the Hampstead home of Shannie Ross when a trainee doctor at the London Spinal Unit at the Royal National Orthopedic Hospital reported that medical treatment was being compromised by inadequate rehabilitation facilities. A group decided to set up Aspire to raise funds to improve those facilities and from that grew the drive to build a whole new rehabilitation unit next to the spinal unit, opening the facilities to the general public. The £2 million-facility was opened in 1999 by HRH the Princess of Wales. It was named the Mike Heaffey Centre after the chairman-elect of the Allied Dunbar Foundation – a major funder of the building. Mike Heaffey had tragically died in 1984 at the age of fifty. In 1998 a further £5 million was raised from the Sports and Arts Lottery as well as from Allied Dunbar, with a major extension incorporating a pool, sports hall, dance studio and café designed by Sir Norman Foster. It was named the Aspire National Training Centre. It is the first of its kind in Europe and is a non-profit making organisation, receiving no statutory funding.

Stanmore Country Park

Pear Wood and Stanmore Country Park lie in the north-eastern corner of the Borough of Harrow and are important ecologically and geologically. The pebble gravels, which help the drainage of the high ground, have been the subject of excavation in the past and here, at Wood Lane, the woodland conceals the banks and ditch of the linear earthwork known as Grim's Dyke. The earliest references to Pear Wood are sixteenth-century and probably refer to the Parys family. The presence of a bank and ditch suggests a boundary earthwork. Evidence from excavations fifty years ago suggest that Grims Ditch, which runs westward to Harrow Weald, is of earlier mould. The legend that Cassivellaunus, the British king of the Catuvellauni, defeated Julius Caesar here in 54 BC was commemorated by the eighteenth-century antiquarian, William Sharpe, who erected this Obelisk in 1750 in the grounds of the hospital. The location of this event is disputed, as is the victory ascribed to the British.

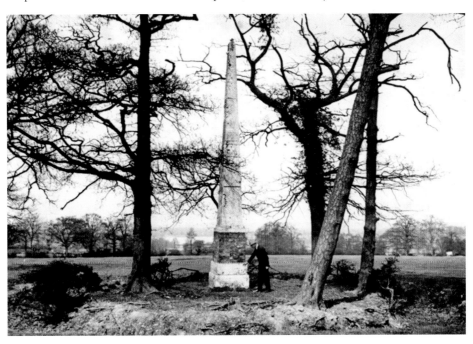

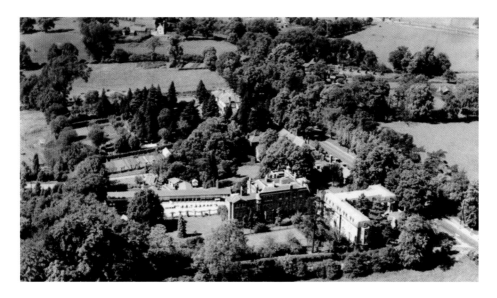

RNO Hospital

The extensive Victorian premises of the Royal National Orthopaedic Hospital (RNOH) at the top of Brockley Hill began as a hospital for children recovering from infectious diseases like scarlet fever and dipththeria. It had been founded by Mary Wardell in 1882 who converted her house while moving to smaller premises next door. The building became a military convalescent home in 1915 and, following her death at the end of the war, it was taken over by the Shaftesbury Society. The property was chosen for the RNOH's country branch and it opened in July 1922. Rapid expansion in the 1920s and the acquisition of Brockley Hill House and its grounds in 1935 continued to improve facilities. The patients' care centre was opened by the Duke of Gloucester in 1977. The Prince of Wales opened the Rehabilitation Assessment Unit in 1979, funded in memory of Graham Hill, and the new Spinal Injuries Unit was opened by the Princess of Wales in March 1984. As a result, the RNOH is the largest orthopaedic hospital in the UK. The hospital works in partnership with University College, London and its Institute of Orthopaedic and Musculoskeletal Science. Healthcare ranges from acute spinal injuries to rehabilitation of chronic back sufferers. This aspect of work gives the hospital a major teaching role. More than 20 per cent of all UK orthopaedic surgeons receive their training here. Plans to develop the site and improve the accommodation for patients, consultants and visitors are in their infancy, maintaining its role as a leader in the field of orthopaedics. (© *English Heritage. NMR Aerofilms collection*).

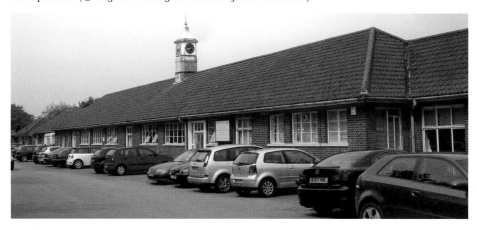

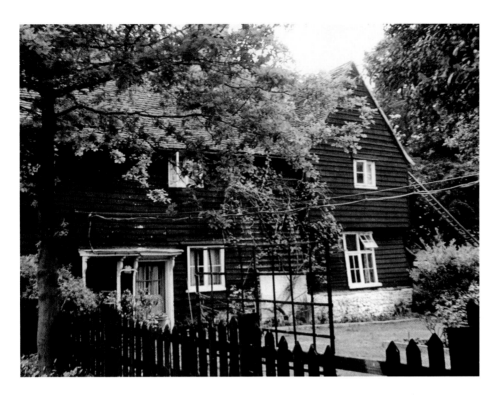

Brockley Hill

Brocklehill House is mentioned in 1717, but fields and hills of that name appear some 400 years earlier. Brockley Hill House stood south of Brockley Hill Farm on the edge of the ridge. It was the home in 1915 of Albert Chevalier, the artiste who made the 'Coster Serenade' song famous at the Welsh Harp Music Hall. The house has recently been demolished and replaced by an impressive and attractive block of flats. Brockley Hill, however, was and remains of steep ascent.

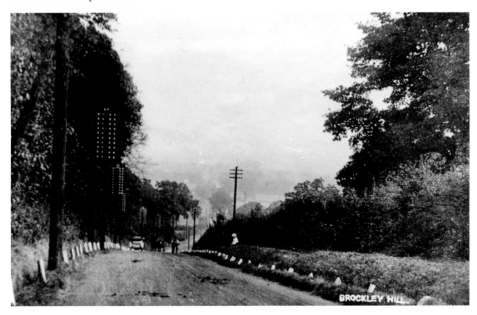

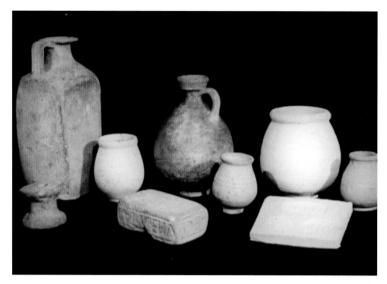
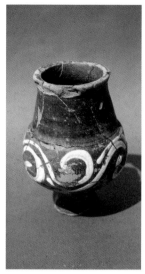

The Roman Settlement

A Roman beaker from Pear Wood (1960s/70s) and ceramics from the Moxton collection (1953), by courtesy of the Museum of London. The earliest evidence of Roman remains at Brockley Hill is of the pottery industry. A posting station may have come later. If *Sulloniacis* was the name of the posting station then it is likely to have been Edgware instead of a hill top. Activity in the area has spanned the whole of the Roman occupation, between AD 43 and 410, with a concentration in the third and fourth centuries. Trading links with London then would have been as vital as they are now. There seems to be little connection between the Stanmore of today and *Sulloniacis*. *Sulloniacis* was the name identified with the Roman station on Brockley Hill. It is mentioned in the *Antonini Itinerarium* (the Antonine Itinerary), which was a list compiled of Roman posting stations in the third to fourth centuries, giving distances along various roads in the Roman Empire. The British section was known as the *Iter Britanniarum*. Of its date or author little is known, but as a map of Roman Britain it appeared to identify the settlement of *Sulloniacis* as a major centre for the pottery industry, attracting excavations since the 1930s.

The pottery factory lay on Watling Street at Brockley Hill, midway between London and St Alban's. Watling Street was busy enough to be maintained as a significant highway for probably 400 years. However busy it may have become, the results of some eighty years of excavation indicate *Sulloniacis* was not a hilltop town. It was separate from the pottery and tile production area though both were sited along Watling Street. The pottery remains, which can be seen in abundance from the period AD 50–160, show it to be a major complex of national importance and the range of new goods made here was large and included perfume pots and amphorae, jugs, bowls and jars. There is nothing however contemporary with the itinerary, nothing that is on the scale of a posting station or 'mansio' which was for official messengers where they could obtain fresh horses to get them over the hills.

At the end of the sixteenth century William Camden concluded this was the place on the Itinerary. Archaeological investigations in the last ten years have revealed extensive Romano-British activity lower down the hill and that from mid-first to mid-second century a town called *Sulloniacis* existed as a hill top clearing in which a large industrial complex straddled an important highway. There are third–fourth-century Roman remains further south on Watling Street on the northern edge perhaps of a settlement or roadside town. Edgware could have met that role as it probably was doing in the twentieth century, but sites have been redeveloped and opportunities for excavation lost.

Celebrities of Stanmore

The story of a township is not only about buildings, how they came to be built and how they have been adapted and used, but it is also about people. While buildings tell a tale by the way they are clad, or clothed architecturally speaking, it is the lives of everyday people with their comings and goings and relationships which help shape its development. Here are just a few with Stanmore connections past and present:

Sir John James Hamilton, Marquess of Abercorn (1756–1818)
It was he who had Bentley Priory re-modelled in 1789–98 by the architect Sir John Soane. The Marquess died leaving it to his grandson because of the death of his children through tuberculosis. His grandson, James Hamilton (1811–85) became the first Duke of Abercorn in 1868. The Second Marquess and his family let out the premises in the 1840s to raise money. The Marquesses are buried at St John's.

George Hamilton-Gordon, 4th Earl of Aberdeen (1784–1860)
Colonial Secretary and Prime Minister in 1852–1855, George Hamilton-Gordon married the Marquess's daughter.

Adelaide Amelia Louise
Adelaide, of Saxe-Meiningen (1792–1849), is perhaps best remembered for the city named after her in South Australia, but she was the wife and widow of King William IV and lived at Bentley Priory from 1848 until her death.

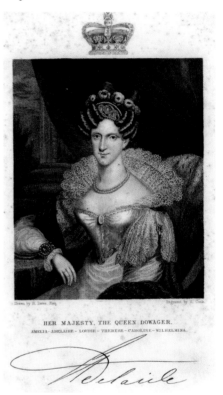

HER MAJESTY, THE QUEEN DOWAGER.
AMELIA-ADELAIDE-LOUISE-THERESE-CAROLINE-WILHELMINA.

Clive Anderson
Anderson was born on 10 December 1952. He is a former British barrister, comedy writer and presenter for television and radio. He was educated at Stanburn Primary School.

Clement Attlee
Attlee, former British Prime Minister (1883–1967), succeeded Churchill in 1945. A resident of Stanmore *Queen Adelaide* from the 1930s until 1946. His house 'Heywood' was by courtesy of St John's Church, later demolished and replaced by a block of flats.

Louisa Thynne, 4th Countess Aylesford (1760–1832)
She was leasing Stanmore Park before 1815 and was still in occupation in 1816. She was the first daughter of the first Marquis of Bath and married Heneage Finch (1751–1812) in November 1789 when she became styled as 4th Countess of Aylesford. Her husband, the 4th Earl of Aylesford, held various titles including Captain of the Yeomen of The Guard 1783–1804, Lord Steward 1804–12 and a trustee of the British Museum.

William Knox D'arcy (1849–1917)

He was one of the principal founders of the oil and petrochemical industry in Iran. The son of a solicitor, his family emigrated to Australia where he joined his father's practice. Speculating in land, he became a director of the Mount Morgan Gold Mine. The fortune he made in gold mining, was spent prospecting for oil in Persia. He was close to being bankrupt when oil was finally discovered in May 1908, the income from which he used to found the Anglo–Persian Oil Company, now British Petroleum. He later returned to England and bought Stanmore Hall, which was considerably enlarged for him in 1885. The east wing and tower were designed by Brightwen, a pupil of Waterhouse and the mansion was redecorated with fine William Morris interiors. He is buried in St John's.

Sir Geoffrey De Havilland (1882–1965)

He was a British aircraft designer who began working for the Aircraft Manufacturing Company in north-west London before setting up his own company at Stag Lane Aerodrome in 1920. The company moved to Hatfield in 1934, while De Havilland came to live in Stanmore at London Road and at Tanglewood Close.

Andrew Drummond (1688–1769)

He came from a family of bankers; moving from Scotland to London in about 1709 or 1712 to found Drummond's bank in 1717. It is now part of the Royal Bank of Scotland group. He had bought a house called Hodgkins at Stanmore by 1729, which was to provide the basis of the Stanmore Park estate where he was resident until his death in 1769. He is buried at St John's Old Church. It was not until 1763 however, that he set about rebuilding the house as a Palladian style mansion, which involved the almost total reconstruction of the building. His son, John Drummond (1723–74), resided at the house with his family but the next in line, his son George Drummond (1758–89), left debts of over £141,000. Stanmore Park and/or House had passed out of Drummond hands by 1839, George Harley Drummond (1783–1855), a son of the above being another spendthrift. The estate had been leased out by the Drummonds or sold to pay debts.

William Schwenck Gilbert (1836–1911) Librettist, dramatist and illustrator, best known for his fourteen comic operettas in partnership with the composer, Sir Arthur Sullivan. From 1893, Gilbert lived nearby at Grims Dyke, and The Libretti for *Utopia Ltd*, and *The Grand Duke*, were written here in 1893 and 1896. The house is now a hotel and Gilbert is buried at St John's.

Frederick Gordon

Frederick Gordon (1835–1904) was born in Ross-on-Wye and his father, a decorator of restaurants, funded his education so he could become a solicitor. His first wife died at the age of twenty-six leaving him with two children. By his second wife, whom he married in 1869, he had nine more, eight of whom were sons. Following the death of his first wife he leased Crosby Hall in Billingsgate to develop it into a series of dining rooms and he aimed his hotel business at the middle class market. Dining rooms met the needs of the business community and he thus established Frascati's and the management of the chain of hotels. By 1890, his chain of Gordon's hotels was worth over £2 million in London alone. With his slogan 'If it's a Gordon it's the best hotel' he built up the largest hotel chain the world had yet seen. His London hotels included the Metropole Hotel in Northumberland Avenue (1880s) (now Corinthia Hotel) and the Grand (1878–79) in Trafalgar. Outside London, he had large hotels at Bexhill, Brighton and Harrowgate, to name a few. His hotel empire was absorbed into the Grand Metropolitan chain in 1963. On the continent he had hotels at Cannes and Monte Carlo. President of the RIBA in 1888–91 and the architect of the Metropole Hotel in Brighton in 1890. That was also the

year the Gordon Hotels chain was founded. Intending to expand his hotel chain into London's countryside, Gordon bought the Bentley Priory Estate in Stanmore for £75,000 in 1881 together with its woodlands and plantations. Bentley Priory opened as a luxury country hotel in 1885, by which time he had built Glenthorn as a family residence. Although he brought his London guests out by coach for a day in the country (the service, reported in 1889, ran from the Metropole to Bentley Priory) access to the hotel itself from London was still not ideal and it remained an issue when Gordon purchased Stanmore Park in 1887 and the Manor House and grounds in 1890. Gordon solved his dilemma by building a branch line of his own to link his estates with the main line at Wealdstone at a cost of £48,000. The Harrow and Stanmore Railway was founded in June 1886 with Gordon as chairman. Construction began in July 1889 on a line terminating at Stanmore station. The station officially opened on 18 December 1890 and he then set about developing the part of his Bentley Priory estate closest to Stanmore station – for housing railway staff. He proposed Gordon Avenue as a road name, along which substantial villas would be built. The branch line was intended to link his estates with the main line so that it could be used by club members to travel to the golf club from London. By the time Gordon had acquired Bentley Priory and Stanmore Park, built the cottage hospital and Manor House, laid out a golf course and built the Stanmore railway with houses for its workers, his land ownership was said to have covered half the parish. His villas were built in orange brick with timber porches. Where the Arts & Crafts design survives in Old Church Lane, and also with Waterhouse's plans of 1891/92 for 26/28 Gordon Avenue, their attractive Edwardian style is quite clear. To provide local amenities, Gordon set about laying out a golf course over Stanmore Park, firstly for his friends and then as a private club which opened in 1893. He died at Monte Carlo where he had been taken ill in March 1904 leaving nearly half a million pounds. Gordon's funeral at Stanmore was attended by crowds, the like of which had not been seen before. A concurrent memorial service was held at St Martin-in-the-Fields.

Anthony Horowitz
Born in Stanmore on 5 April 1956. He is a novelist and screen writer famous for *Foyles War*, *Midsomer Murders* and the Alec Rider series of children's spy thrillers.

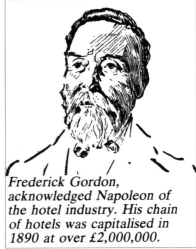

Frederick Gordon, acknowledged Napoleon of the hotel industry. His chain of hotels was capitalised in 1890 at over £2,000,000.

Robert Hollond MP (1808–1877)

Stanmore Hall was the home of Robert Hollond who flew in a balloon to Germany in what would be regarded as the early days of flight. Further flights took place in the 1830s before the flight of the great Nassau balloon of 1840. He was a lawyer and MP for Hastings, and one of three who on 7–8 November 1836 travelled by balloon from the Vauxhall Gardens to Weilburgh, in the German province of Nassau. His companions were the balloonist, Charles Green (whose first balloon journey had been in 1821 to celebrate the Coronation) and Monck Mason, a writer and musician. They accomplished 500 miles in 18 hours, thereby setting a record not beaten until 1907. He is buried at St John's. The story was related one year later in the Revd Barham's *Ingoldsby Legends (By courtesy of City of Norwich Museums)*:

Oh! the balloon, the great balloon
It left Vauxhall one Monday at noon
And everyone said we should hear of it soon
With news from Aleppo or Scanderoon.
But very soon after, folks changed their tune:
"The netting had burst- the silk- the shalloon;
It had met with a trade-wind- a deuced monsoon-
It was blown out to sea- it was blown to the moon-
They ought to have put off their journey till June;
Sure none but a donkey, a goose, or baboon
Would go up, in November, in any balloon!"
Then they talk'd about Green
"Oh! Where's Mister Green?
And where's Mr. Hollond who hired the machine?

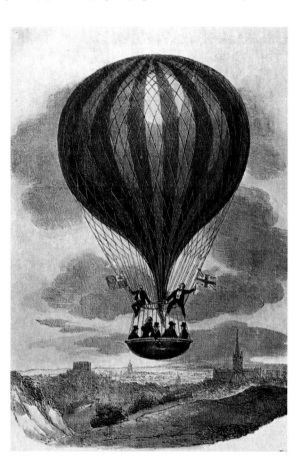

Charles Edward Keyser (1847–1929)

Keyser was key in purifying drinking water and thereby eradicating typhoid, epidemics of which swept London in the 1860s. He was a patron of the Bushey Masonic school and first chairman of the Colne Valley Water Company. He was the President of the British Archaeological Association and lived at Warren House. He devoted his wealth to promoting the happiness of others.

Louis XVIII (1755–1824)

The King of France had been living in exile at Hartwell House in Buckinghamshire in accommodation let to him and the French Court by its owner, Sir Charles Lee, between 1809 and 1814. The coalition of European powers sought to restore the Bourbon Dynasty, of which the Prince Regent, as a member of the European monarchy, had been a keen supporter. Louis proposed to return to France now that the time was right. He left Hartwell to meet the Prince Regent at the Abercorn Arms on Stanmore Hill at 14.00 hours, on 20 April 1814. The Marquis of Abercorn invited the party to Bentley Priory, which was declined. The town of Stanmore exhibited the most novel sight possible to be conceived; there was not a house, but exhibited tokens of respect by the emblems of white – some, to show their zeal to a great extent, actually displayed sheets and pillowcases. Every person who could muster a horse went on horseback a mile out of town, to accompany him into Stanmore. They left for London at 15.00 hours, while dignitaries had left Carlton House for Stanmore to ensure crowds would line the route. Louis's brief reign lasted from the defeat of Napoleon in April 1814 until his own death in 1824. This excluded the 111 days in 1815, which Louis spent in exile until the battle of Waterloo. After the defeat of Napoleon at Waterloo in June 1815, Louis returned to Paris in safety.

Roger G. Moore

He was born on 14 October 1927, is an actor famous for his roles in *The Saint* and as *James Bond*. He lived in Gordon Avenue, Stanmore.

Sir Frederick Handley Page (1885–1962)

The Aircraft Company founded by him came into being near Barking in June 1909. By 1917 a new factory was compulsorily purchased with 160 acres of aerodrome laid out alongside in Claremont Road. This Aerodrome was closed in November 1929 but a new airfield received a Royal opening at Radlett in July 1930. Handley Page lived in Limes House on Stanmore Hill.

Michael D. X. Portillo

He was born on 26 May 1953 and is a British journalist, broadcaster and former politician who went to school at Stanburn primary school.

Sir Herbert J. Seddon (1903–1977)

He was a ground breaking professor of orthopaedics at the Royal National Orthopedic Hospital, where he was resident surgeon from 1931 to 1940 and a professor and consultant surgeon until 1967. He is buried at St John's.

Michael Westmacott

Born in 1925 he left the Indian Army in 1947, while at Oxford University. He started climbing in the UK and European Alps and was a member of the 1953 Everest expedition led by John Hunt. He was president of the Alpine Club between 1993 and 1995. Later in life he was a resident of Gordon Avenue and was Michael married the daughter of Sir Herbert Seddon.

Observations

Since the 1960s many a house with large garden in Stanmore has attracted developers' intent on demolition. Stanmore has not been unique in this but over time, the disappearance of buildings from one plot or another has had an effect on Stanmore's architectural heritage and the village character, which once could be identified with it. Stanmore has been slow to develop, but over the last fifty years notable changes have occurred. The impact of that concentration and the speed of change for many have been sufficient to transform the landscape within a lifetime. Not surprisingly residents who have ties with the area will be concerned to see the removal of scenes they cherish. Challenging new designs can be as controversial as the demolition of people's homes and streets. In that process of change, slices of history have come and gone and we should be committed to recording these changes if future generations are to remember how life in Stanmore has changed through time. I am indebted to those who have done just that.

Acknowledgements

Air Pic; Bentley Priory Battle of Britain Trust; Canons Community Centre (John Benn); City and Country (Jo Ridehalgh); Collins-Bartholemew; Grimsdyke Service Station (Doreen Evans); London Borough of Harrow; Harrow Local History Library (Hazel Ogilvie); *Harrow Gazette and Observer*; Latitude Mapping Ltd; London Transport Museum collection; Museum of London (Cath Maloney); National Portrait Gallery; Friends of Norwich Cathedral; Stanmore College (David Knowles); Stanmore Society (John Williams).

Late Roy Abbott; Malcolm Barres-Baker; Mark Biddle; Brenda Bostock; Eileen Bowlt, Michael Bradshaw; Anthony Breslauer; Brent Archives; J. E. Connor; Jean Cooper; A. Neil Davenport; Tony Donetti; Anne Drakeford; W. W. Druett; Martin Ellison; Erica Ferguson; Anna Fox; Anthony Gray, Trevor Gray; Marna Hawkins; Owner of Heriots; Susan Hewlett; Dr Freddie Hicks; Barry Ingate; Rosamund King; Revd Shaun Lambert; Angy Lawrence; late E. J. Leversuch; Helen McLaughlin; Rick and Anne Morgan; Hazel Ogilvie; William Ohene; Dr GDS Pallawela; Alf Porter; Roddie Porter; Ken Reyland; Freda Richards; Barbara Robbens; Joseph Roth; Revd Christine Robinson; Peter G. Scott; Ben & Viv Sharkey; Derek Taylor; Richard & Alison Theobald; Dr Isobel Thompson; Eileen Tucker; Don Walter; John Williams; Frank Willis; and Tony Wood.